BASEBALL IN ALTOONA
FROM THE MOUNTAIN CITY TO THE CURVE

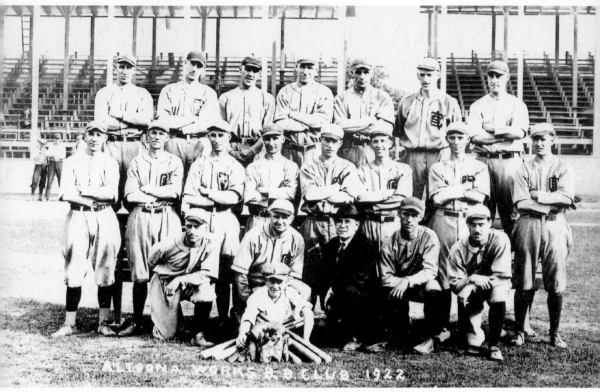

While no professional baseball team in the history of the city of Altoona ever won a league title, in 1922 the Altoona Car Shops team, pictured above, captured the Pennsylvania Railroad world championship against a club from Fort Wayne, Indiana. Its championship was one of many great moments that the fans of the national pastime have enjoyed in Altoona. (Courtesy of the Railroaders Memorial Museum.)

On the front cover: Please see page 84. (Courtesy of the Altoona Curve.)
On the back cover: Please see page 19. (Author's collection.)
Cover background: Please see page 29. (Courtesy of the Railroaders Memorial Museum.)

BASEBALL IN ALTOONA
FROM THE MOUNTAIN CITY TO THE CURVE

David Finoli

ARCADIA
PUBLISHING

To my parents, Domenic and Eleanor Finoli,

who have inspired me to the fulfilling life I lead today

Published by Arcadia Publishing
Charleston SC, Chicago IL, Portsmouth NH, San Francisco CA

Printed in the United States of America

Library of Congress Catalog Card Number: 2007931494

For all general information contact Arcadia Publishing at:
Telephone 843-853-2070
Fax 843-853-0044
E-mail sales@arcadiapublishing.com
For customer service and orders:
Toll-Free 1-888-313-2665

Visit us on the Internet at www.arcadiapublishing.com

CONTENTS

ACKNOWLEDGMENTS

A project of this kind is impossible without the support of both friends and family. Thank you to my lovely wife, Vivian, and my incredible children, Cara, Matthew, and Tony, who make every day worthwhile. Also a thank-you goes to my parents, my brother Jamie and his wife, Cindy, my sister Mary and her husband, Matthew, and my nieces Marissa and Brianna.

On the research side, the fine people of the Blair County Historical Society, including curator Joan Thompson, and the Railroaders Memorial Museum staff and their executive director Scott Cessna were all extremely valuable resources of the exciting history of the national pastime in this scenic community. For information on the current brand of baseball that is played in Altoona, Jon Laaser and Jason Dambach of the city's very successful minor-league franchise the Curve went over and above the call of duty contributing any photograph and piece of information that I needed to complete this project. A thank-you also goes to Jim Trdinich from the Pittsburgh Pirates who donated many great photographs of Curve alumni who lived their dream.

Last but not least a thank-you to Tiffany Howe and her fine staff at Arcadia Publishing who not only have been a joy to work but are among the most productive and professional publishing firms I have had the pleasure to deal with.

Unless otherwise noted, all images are from my personal collection.

INTRODUCTION

For 46 days in the spring of 1884, the small town of Altoona was on the big stage in the baseball world. It secured a major-league franchise in the upstart Union Association that was hell-bent on breaking the monopoly that the National League and American Association had held on the national pastime in its early years. After 25 less-than-stellar games, in which the Mountain City went 6-19, averaging only 1,000 fans a game, Altoona moved off to Kansas City.

This was the beginning of an unfortunate string for the city of Altoona, one that would see it produce one unsuccessful franchise after another. Between 1892 and 1931, the city hosted four different minor-league teams. There was the memorable Altoona Mud Turtles that began in the Pennsylvania State League in 1892 before leaving for Lancaster in the midst of the 1894 campaign. Ten years later, the Mountaineers came to town. They were the most successful of the four, playing six seasons in the Tri-State League, garnering three .500-plus records in the process. The Rams moved into Altoona in 1912, giving the city a team once again in the Tri-State League. This club lasted a mere 35 games before moving on to Reading by mid-June.

Finally there was the ill-fated Altoona Engineers of the Mid-Atlantic League in 1931, a team that started the season in Jeannette and ended in Beaver Falls at the bottom of the circuit. It would be 65 years until the city saw another professional baseball game when the Rail Kings sauntered into town.

Despite the fact Altoona had gone so long without a professional team, it had a wonderful track record of amateur baseball, some of which was played by the railroaders at the beginning of the 20th century. The same men who helped give the city its unique personality as one of the railroading hubs of the country played baseball at the highest level. There were the Juniata YMCA, the Makdads, the Altoona Machine Shops, and the Altoona Car Shops teams, which were among many squads that would entertain the baseball fans of Altoona. Even though these clubs had success, there was still a huge void without professional baseball. With its abysmal history in the past, there were doubts whether the city would ever get another franchise.

Finally in 1996 came the Rail Kings, an independent club playing in the small North Atlantic League. A year later, they moved to the equally diminutive Heartland League after the North Atlantic League folded. Things were a little different this time. For the first time in the city's history, a professional baseball team did not fail. Altoona averaged over 30,000 a year both seasons, which was a very formidable figure for those circuits, finishing second and third in the league, respectively. As good as the attendance was, it was hardly a predictor of what was to come.

With the addition of Tampa Bay and Arizona to the majors in 1998, it meant that each minor-league classification would need to add two teams. While it looked like Springfield, Massachusetts, would be the choice for the second Double-A franchise along with Erie, Springfield was unable to get the financing for a stadium. Altoona natives Bob Lozinak and Tate

DeWeese came into the picture. The duo was able to put forth the financing for the team, but a facility that was formidable enough to house a prospective Double-A franchise still needed to be finalized. Veterans Memorial Field, more commonly known as Vet's Field, was not a suitable stadium for that level of professional ball, so money needed to be found somewhere. The state legislature came forward, putting together a stadium proposal in 1997, paving the way for a team in Altoona to play at the highest level of professional baseball since those fateful 46 days some 113 years before. That team would be named after the city's most notable site, Horseshoe Curve, and be called the Altoona Curve.

The facility the state provided Altoona not only was incredible but was a park that was the envy of most professional teams. The stadium was named Blair County Ballpark. With a classic roller coaster leering over the right field fence, USA Today described it in 2002, claiming that "a minor league ballpark is one thing. An amusement park is another. But tucked in the Allegheny Mountains is a place where there's really no difference."

Inside the phenomenal facility, the team proved to be a huge success from the beginning, consistently averaging 5,300 fans per game over its nine-year history. Even though they were a success at the gate, the Curve never was able to translate that to the win-loss column, that is until a group led by Chuck Greenberg, Mario Lemieux, and Jerome Bettis took over in 2002. Greenberg and company, formally known as Curve Baseball LP, would completely remake the franchise. They made major improvements in their already impeccable stadium, which included becoming one of the few Eastern League teams to add outfield seating, expanding the stadium's capacity by almost 2,000 to 7,210, (over 9,000 with standing-room capabilities). The group also added a section in right field called the Rail Kings where fans get a unique view of the game while having television capabilities, access to a waiter or waitress, and press game notes, as well as an expanded picnic area and a party deck. It gave the great fans of this lovely city an even better experience at this majestic ballpark.

With all the work to the stadium, improvement with the team was essential too. That came a year later in 2003 when the Curve qualified for their first postseason appearance. It was something that would become a habit as the club made the Eastern League playoffs four consecutive seasons, including capturing the 2004 Southern Division championship.

The effort Curve Baseball LP put into improving the flourishing franchise did not go unrewarded as it was given the ultimate honor by capturing the prestigious John H. Johnson Presidents Trophy in 2006, awarded to the top franchise in all of minor-league baseball. The award was a moment that showed the baseball world just how far this city has come, from a town that could not support a professional team to one that is now one of the true jewels of minor-league baseball.

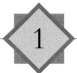

THE STADIUMS

On April 10, 1884, a large group of groundskeepers worked feverishly on the infield of Columbia Park, or the Fourth Avenue grounds as it was also known, in preparation for the first game ever played by the Altoona Mountain City of the Union Association, the city's short-lived major-league baseball team. With the team facing Logan in the club's inaugural exhibition game the following day, the local newspaper, the *Altoona Morning Tribune*, described the infield as having "been greatly improved and will be one of the best in the state." One hundred and fifteen years later, construction workers and groundskeepers alike created another jewel, called Blair County Ballpark, in this quaint city, giving Altoona not only one of the so-called best infields in the state but one of the finest minor-league facilities in the country.

Other than the fact they both housed professional teams and had fine infields, there are few things that are similar about the two stadiums. The modernization of today's ballparks explains most of the differences, but perhaps the most striking comparison is the amount of patrons entering each facility. Fewer than 1,000 per game followed the trials and tribulation of the Mountain City, ending Altoona's major-league experiment only 25 games into it. In contrast, over three million fans have jammed into the friendly confines of Blair County Ballpark, an average of 5,300 a contest over a nine-year period, making Altoona a bigger draw than such markets as New Orleans, Las Vegas, Omaha, and San Antonio.

There have been other fine stadiums in Altoona such as Cricket Field, which was host to the many fine railroader teams at the beginning of the 20th century, Pennsylvania Railroad Park, the neutral site home of the Homestead Grays, which had an inviting right field fence that was only 150 feet away, and Veterans Memorial Field, otherwise known as Vet's Field, where the Rail Kings played in the 1990s. Vet's Field is a fine facility for amateur baseball as well as an independent league club but would not have been able to sufficiently house a Double-A club, which its successor, Blair County Ballpark, is more than able to. The following page lists ballpark statistics for both Vet's Field and Blair County Ballpark.

Veterans Memorial Field
Capacity: 3,000
Record season attendance: 33,019 (1996)
Total attendance for the Altoona Rail Kings: 63,651 (1996–1997)
Right field: 325 feet
Right-center field: 356 feet
Left-center field: 383 feet
Left field: 348 feet
Home of: Altoona Rail Kings (1996–1997)

Blair County Ballpark
Capacity: 7,210 (seating), 9,300 (standing room included)
Record capacity (regular season): 9,255 versus Harrisburg on August 10, 2003
Record capacity (Eastern League All-Star Game): 9,308 on August 12, 2006
Record season attendance: 394,062 (2004)
Total attendance for the Altoona Curve: 3,241,510 (1999–2007)
Date opened: April 16, 1999, versus Bowie (won 6-1, attendance 6,171)
Right field: 325 feet
Right-center field: 375 feet
Center field: 405 feet
Left-center field: 365 feet
Left field: 325 feet
Home of: Altoona Curve (1999–2007)

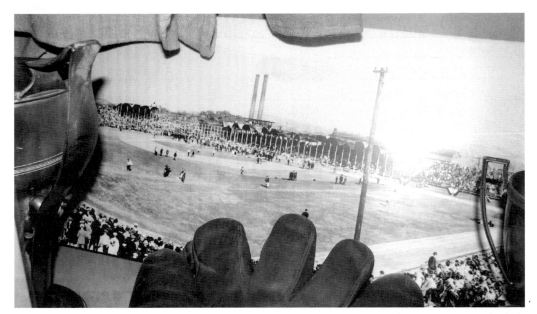

Cricket Field, named after the famed British sport to try to impress British investors, was the hub of baseball in Altoona at the early part of the 20th century. Upward of 30,000 people used to come from throughout the area to see major-league and Negro League exhibition contests. Here a packed crowd turns out to see Babe Ruth play with a team of local players on October 3, 1924.

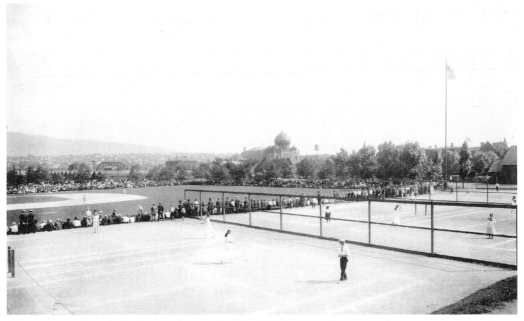

Thousands of baseball fans gather at Cricket Field to watch a game between the Harrisburg Senators and the Altoona Mountaineers in a Tri-State League matchup on August 2, 1906. Cricket Field offered something for everyone, as several tennis players enjoy playing a match in the courts that were located above right field. (Courtesy of the Railroaders Memorial Museum.)

Playing home to the Independent League Altoona Rail Kings in the mid-1990s, Vet's Field helped usher in a new era of professional baseball in Altoona after a 65-year absence. One of the most unique features of the field is the view of the Jaffa Shrine from the third base stands.

Vet's Field was home to the Rail Kings for two seasons, in 1996 and 1997. Following the independent league club's departure to Huntingdon, West Virginia, in 1998, the ballpark's days of hosting professional baseball were over. Since then many amateur events have taken place there such as the National Amateur Baseball Federation regional tournament that annually makes a stop at this classic venue.

Landscapers work feverishly to get the infield of Vet's Park ready for the 2007 National Amateur Baseball Federation Senior Division regional tournament that was played at the facility in July 2007 (above). The souvenir/concession stand (below) also saw lots of activity that week. During the park's heyday in the mid-1990s, many fans of the national pastime went through the gates of this classic facility to see the Rail Kings. In 1996, the team drew a league second-best 33,109 fans. The following season, when the club moved to the Heartland League, the Kings had another fine season at the gate as 30,632 patrons came to see the team win the first-half North Division championship.

This plaque, located right outside the main gate at Blair County Ballpark, honors the men who built this magnificent facility. LD Astarino Companies, an architectural firm from Pittsburgh, designed the stadium, while Ralph J. Albarano and Sons, a contractor firm from nearby Duncansville, did a wonderful job making this park one of the gems of minor-league baseball.

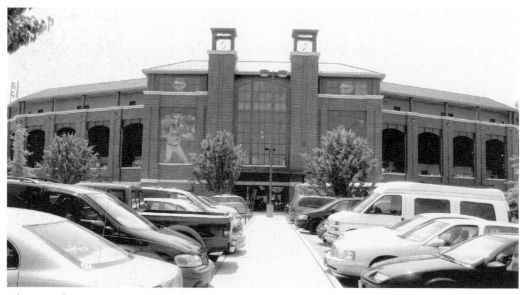

Above is the entrance to Blair County Ballpark, home of the Altoona Curve from the Eastern League. As the team was named to celebrate the railroading industry that made this city of 49,000 famous, so too was the stadium designed to honor it. LD Astarino Companies designed the facility to emulate a railroad roadhouse. (Courtesy of the Altoona Curve.)

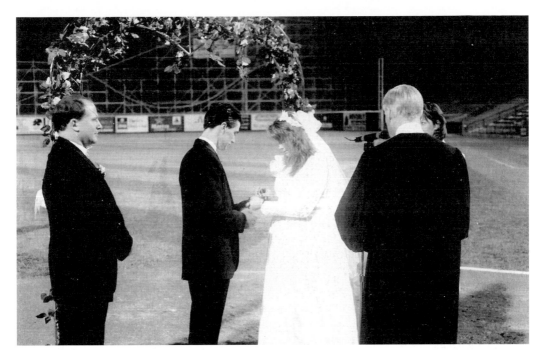

Part of the whole ballpark experience at minor-league baseball games is about unique promotions and having fun. The image above shows two Curve fans getting married the ultimate way, at home plate at Blair County Ballpark, while at right is one of the interesting blow-up figures that greets fans as they enter the right field gates. Over its nine-season existence, the front office of the Curve has shown an uncanny ability to come up with unique promotions, including its Retro Celebrity Series that brought classic television stars from the 1970s and 1980s such as Jamie Farr, Erik Estrada, and Jerry Mathers to the park. For all its efforts, the Curve front office was awarded the prestigious Larry MacPhail Trophy in 2004 as the minor league's top promotional franchise. (Above, courtesy of the Altoona Curve.)

BASEBALL IN ALTOONA

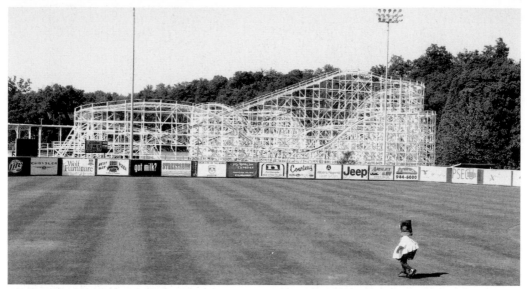

Greeting fans from beyond the right field wall is one of Blair County Ballpark's signature sights, a wooden roller coaster called the Skyliner located at the adjacent amusement park, Lakemont Park. On May 14, 2002, Curve play-by-play man Rob Egan broadcast what was believed to be a baseball first when he called the first three innings of a game against New Haven from on top of the Skyliner.

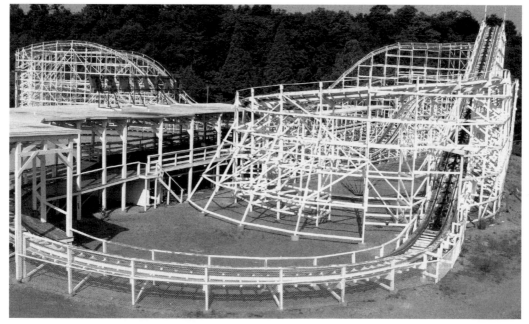

The Skyliner was built in 1960 in Canandaigua, New York, at Rosemont Park. It was moved to Lakemont Park in 1987 and is one of two wooden roller coasters at Lakemont. The other is a tad more famous one called the Leap-the-Dips, which is the world's oldest operating wooden roller coaster, built in 1902.

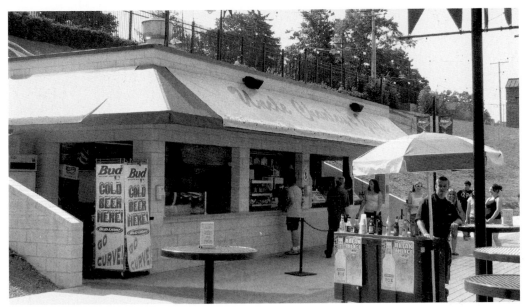

One of the biggest changes in minor-league parks over the last couple decades has been the inclusion of phenomenal specialty food concession stands. In Altoona, one such place is Uncle Charley's Grille. The signature food at the stand is Uncle Charley's sausage sandwich, one of the tastiest ballpark treats around.

Located over Uncle Charley's Grille and the visiting bullpen in left field is another memorable landmark in Blair County Ballpark, the Altoona Curve lettering that is etched in the upper grass area. "Irish" Pat Coakley, who is the 2005 and 2006 Eastern League Groundskeeper of the Year, and his staff created this masterpiece in March 2007.

One of the biggest changes at the ballpark that Chuck Greenberg and his group made when they took over the Curve was to add extra seating over the left field wall. In the picture above, behind the outfield wall is overrun with tall grass, as there is no nice bullpen, no generous picnic area, no Rail King section, and, sadly enough, no Uncle Charley's Grille. Before the 2003 campaign, construction went up for the outfield section that seats 744 people. The addition increased the ballpark capacity to 7,210 fans (9,300 with standing room included). To make the space, the team moved the fences in 10 feet and the wall was lowered 3 feet. When it was built, it was only the third Eastern League facility to offer outfield seating. (Above, courtesy of the Altoona Curve.)

THE STADIUMS

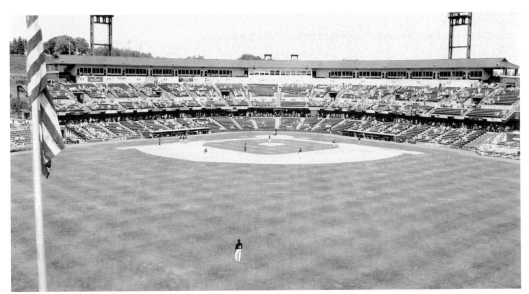

A view from above the outfield wall of Blair County Ballpark as the Curve looks on during a game against the Akron Aeros shows the double-deck design of the facility. The purpose of constructing the stadium this way was to allow the fans walking through the concourse on both levels a more generous area to walk and move around freely.

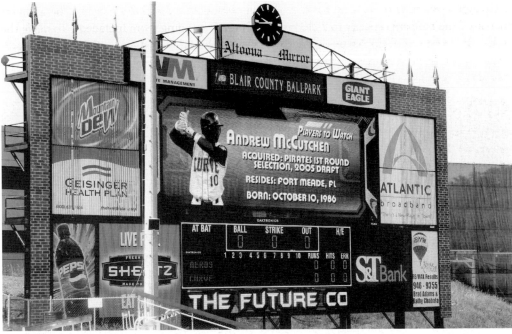

The biggest addition to the stadium before the 2006 campaign was a massive scoreboard above the left-center field wall; it is telling fans about of the club's most prized prospect of 2007 in the picture above. The 1,000-square-foot wall cost $1 million and is among the largest scoreboards in all of minor-league baseball.

As fans enter the front gates of Blair County Ballpark, they can see pictures of some of the greatest players in team history. Here is "Big Country" Brad Eldred, who is one of the premier sluggers in the annals of Curve baseball, hitting 30 home runs in his one-plus season for Altoona.

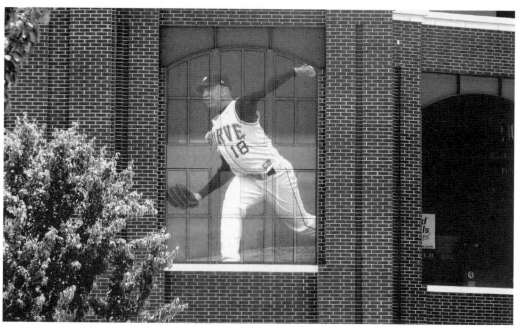

Right next to Eldred is pitcher Sean Burnett, who won the second-most games by a Curve pitcher in a season with 14 in 2003. After being named the Pirates organization's Pitcher of the Year in 2001–2002, the former first-round pick's major-league dreams were derailed when he hurt his left elbow during his rookie campaign for the Bucs in 2004.

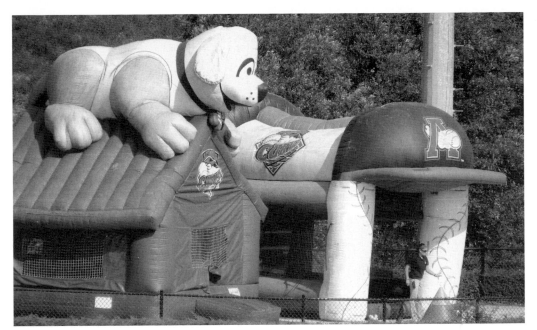

In the stands down the right field line is a place where kids can go to have a great time, two huge moonwalk facilities. Next to the one on the right, the one with the Curve hat, is the Dawg house that helps celebrate the Curve's more recent mascot Diesel Dawg. On the field, Diesel Dawg teams up with the club's more famous original mascot, the green-clad Steamer.

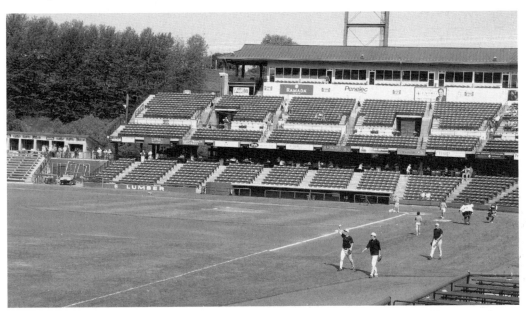

Above is the view fans get from one of the club's stadium enhancements in 2003, a row of seats in left field called the Rail Kings. Here fans are treated to a wonderful experience that includes cable television, game notes, and access to waiters and waitresses. It is a great view that ESPN recently rated as the third-best seating section in all of minor-league baseball.

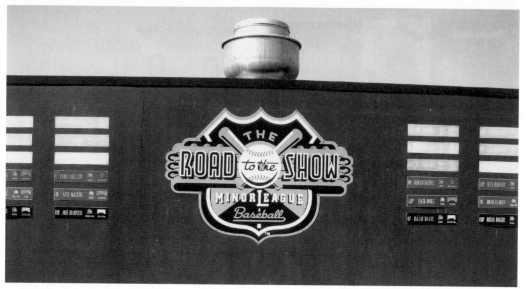

Down the left field line is an area the team created to honor the members of the Curve who have lived the ultimate dream of all minor-league players and made it to the show. This area, called Road to the Show, has plaques of Curve members who reached the majors. The plaques include their names, their time spent with the Curve, and the team and year they debuted in the majors.

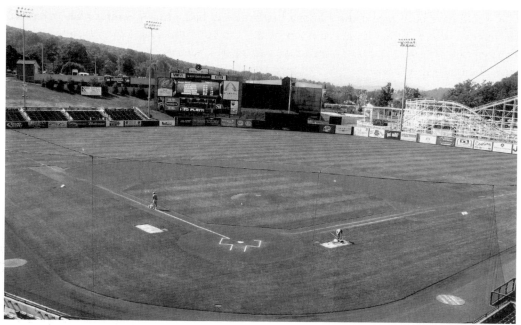

"A minor league ballpark is one thing. An amusement park is another. But tucked in the Allegheny Mountains is a place where there's really no difference," said *USA Today* about Blair County Ballpark in an article on August 8, 2002. There are few parks in the country that are as scenic as this one, a real gem for baseball fans in this part of the state to enjoy.

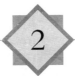

2

BEFORE THE CURVE

It began with such fanfare, Altoona's short dip into the major-league waters. The Mountain City scored a run in the first inning of the first game against Cincinnati on April 17, 1884, a contest where catcher Jerrie Moore became a temporary hero by smacking the initial homer in Altoona Mountain City history (his lone major-league long ball). It would be the only fanfare in the club's short existence. It dropped the first two games to Cincinnati by a combined 16-4, blew its home opener against St. Louis, 15-2, a game where the scribes at the *Altoona Morning Tribune* made the unfortunate claim that "there is good material in the home team," and it never looked back.

Forty-six days later, the miserable attempt at major-league baseball in Altoona came to an end when 600 fans saw Baltimore plate two runs in the eighth en route to a 5-3 victory. The loss dropped Altoona to 6-19 and put it on a one-way train ride to Kansas City, where it finished the season.

It would have been nice if the Altoona baseball story had a happy ending when it entered the minor-league wars, but it did not as four teams came and four teams went, ending with the Engineers in 1931, who could not even finish one season. There was some success at the amateur level, though, with the men who worked for the Pennsylvania Railroad (PRR) and represented the various shops proudly on the diamond. The Altoona Machine Shops, the Juniata Shops, and the Altoona Car Shops, the 1922 PRR world series champions, were the kings of the Altoona PRR scene, producing some fine players, including pitchers Henery Leisure and Chris Davis, who signed with Nashville of the Southern Association.

In professional ball, though, the city was void of a team for 65 years until the Rail Kings moved into the friendly confines of Vet's Field, looking to end the drudgery that was Altoona professional baseball. While the team was in existence only two years, they were good years at the gate that showed the powers that be that baseball in Altoona could succeed, a fact the Curve have proven since. The following page outlines the Altoona teams' statistics from the Mountain City to the Rail Kings.

The Mountain City (or Unions)
Union Association

Year	Wins	Losses	Percentage	Place
1884	6	19	.240	10th*

*moved to Kansas City where they went 16-63

The Mud Turtles
Pennsylvania State League

Year	Wins	Losses	Percentage	Place
1892	23	15	.606	3rd
1893	57	41	.582	3rd
1894	17	31	.354	7th*

*moved to Lancaster on July 7 and finished the season 51-54

The Mountaineers
Tri-State League

Year	Wins	Losses	Percentage	Place
1904	50	48	.516	4th
1905	52	73	.416	6th
1906	64	62	.514	4th
1907	61	61	.500	5th
1908	49	78	.386	7th
1909	59	55	.518	4th

The Rams
Tri-State League

Year	Wins	Losses	Percentage	Place
1912	14	21	.400	6th*

*moved to Reading on June 13 and finished the season 52-59

The Engineers
Mid-Atlantic League

Year	Wins	Losses	Percentage	Place
1931	17	43	.283	12th*

*moved from Jeannette after a 1-11 start on May 23 and moved to Beaver Falls on July 18, finishing 32-96 total for the year

The Rail Kings
North Atlantic League

Year	Wins	Losses	Percentage	Place
1996	36	42	.461	4th

Heartland League

Year	Wins	Losses	Percentage	Place
1997	36	36	.500	1st (1st half), 3rd (2nd half)*

* defeated by Anderson 2-0 in the first-round series (best of three)

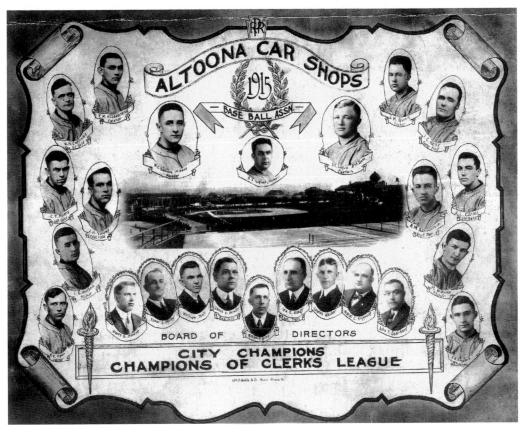

Manager W. C. Bashore, top left-hand corner, led the Altoona Car Shops baseball team to the 1915 Clerks League championship. Opened in 1869 when it became too cramped at the Altoona Machine Shops, the Altoona Car Shops' primary use when it was built was to service freight and passenger cars for the PRR. (Courtesy of the Railroaders Memorial Museum.)

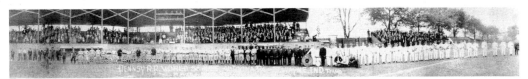

The photograph above shows the combatants for supremacy of the PRR as Altoona and Fort Wayne square off in the 1922 PRR world series in Lima, Ohio. The team representing the Altoona Car Shops would emerge victorious, bringing the PRR world championship back to this Pennsylvania railroad hub. (Courtesy of the Railroaders Memorial Museum.)

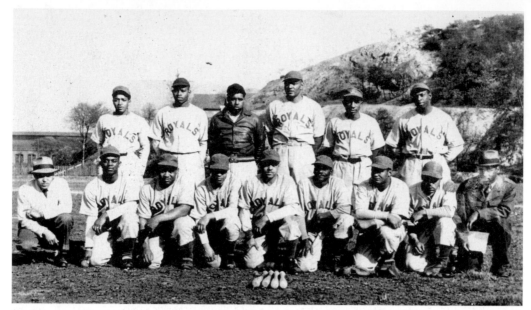

During the early part of the 20th century, African American baseball flourished in Pennsylvania. Shown here are two local teams, the Royals pictured on top and the Makdad club below. Because Altoona was a strategic stopover on the railroad system, many professional teams would come and play exhibition games, which included some of the greatest Negro League players in the history of the national pastime. Crowds would gather at the 35,000-seat Cricket Field to see the likes of such immortals as hall of famers Josh Gibson, and his prodigious home run power, and the one and only Satchel Paige, who debuted in the major leagues at the ripe old age of 48. (Courtesy of the Railroaders Memorial Museum.)

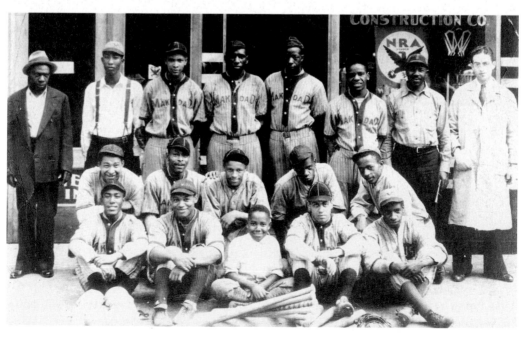

BEFORE THE CURVE

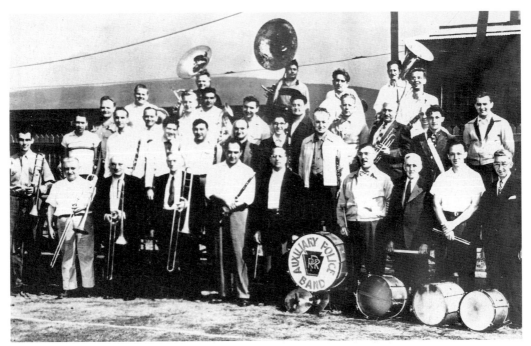

Playing before a game at Cricket Field is the PRR's police auxiliary band. Whether it be baseball, basketball, or playing in the band, the PRR sponsored many activities for its employees. During the late 1800s and early 1900s, both the city and PRR would provide bands and entertainment for many parades that, as the display at the Railroaders Memorial Museum states, "reinforced the company's role in Altoona life." (Courtesy of the Railroaders Memorial Museum.)

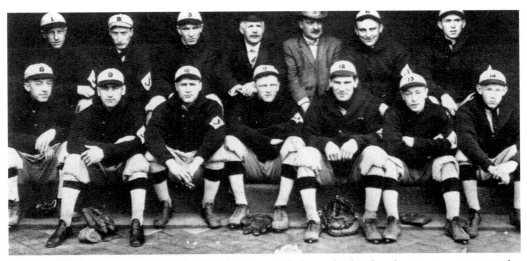

The Juniata Clerks League baseball team, pictured above, had a fine legacy representing the PRR system in the national pastime. Built between 1888 and 1890, as the PRR was in desperate need of more space to build locomotives for its growing empire, the Juniata Shops, which the team represented, quickly was up and running, completing its first locomotive by July 1891. (Courtesy of the Railroaders Memorial Museum.)

BASEBALL IN ALTOONA

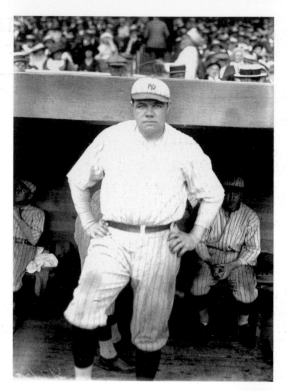

On October 3, 1924, Altoona baseball fans got the thrill of a lifetime when Yankees Babe Ruth and Bob Meusel came to the city for an exhibition game. The Bambino himself, pictured here, thrilled the huge throng and played for a team called the Altoona Indies. Ruth went four for four that day, including a mammoth second-inning home run over the center field flagpole and a long double into the right field seats. (Courtesy of the Library of Congress, Prints and Photographs Division.)

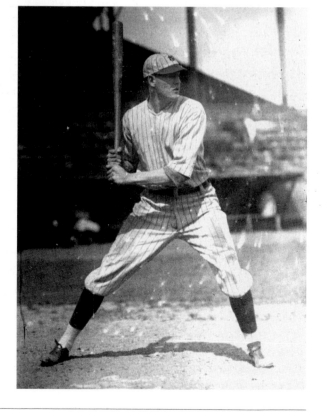

Bob Meusel was the other part of the Yankee duo that visited Altoona that special day. While Ruth played for the Indies, Meusel played for a team representing the Jaffa Shrine. The Indies ripped apart the shrine team 11-2, but the .309 career hitter matched Ruth hit for hit, also going four for four with a homer and double, scoring both runs for his team. (Courtesy of the Library of Congress, Prints and Photographs Division.)

BEFORE THE CURVE

Above is the 1910–1911 Altoona Machine Shops baseball team. The Altoona Machine Shops in the early 1900s were part of the PRR, of which the machine shops were one of four complexes. In their heyday, the complexes included 122 buildings on 242 acres, employing 16,500 workers. (Courtesy of the Railroaders Memorial Museum.)

The Juniata Shops produced many successful teams over its years of playing competitive baseball. It also had the distinction of being the largest producer of the K4 locomotive for the PRR. The K4 was the premier passenger steam engine in the first half of the 1900s, akin to the Boeing 747 in airline travel. The Altoona Curve mascot Steamer was modeled after a K4 engine. (Courtesy of the Railroaders Memorial Museum.)

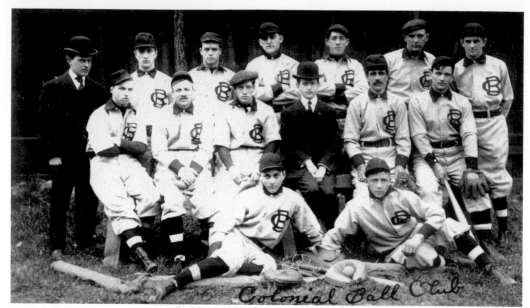

In the picture above is the Colonial Baseball team while below is a collection of railroad baseball all-stars. During the heyday of the PRR between the late 1800s and the first half of the 20th century, the company sponsored many activities for its workers, from symphonies to marching bands to many sports. The purpose was to build morale and pride among the different shops. The company's main focus throughout all the activities it sponsored was to field the best baseball teams possible. The PRR would recruit workers from anywhere to play on its teams. It would offer jobs to these fine players to get them to play on its teams while they worked with the railroad, and when their playing days were done, they would have a job with the PRR. (Courtesy of the Railroaders Memorial Museum.)

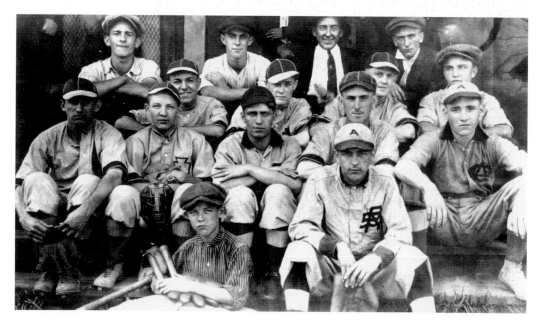

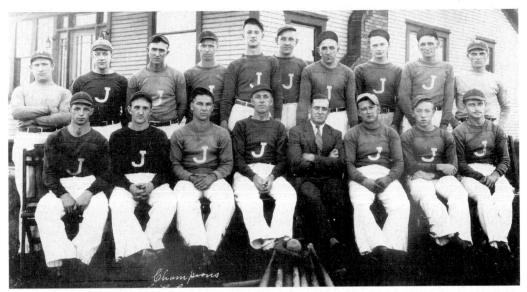

The Juniata Shops baseball team took the Clerks League championship in 1935. During the prime time of railroad baseball, the games were very competitive, and the workers who played for the teams were given special considerations and perks. By the 1930s, though, when Juniata won this title, the competitions, perks, and excitement began to diminish, and the leagues were no longer as important as they used to be. (Courtesy of the Railroaders Memorial Museum.)

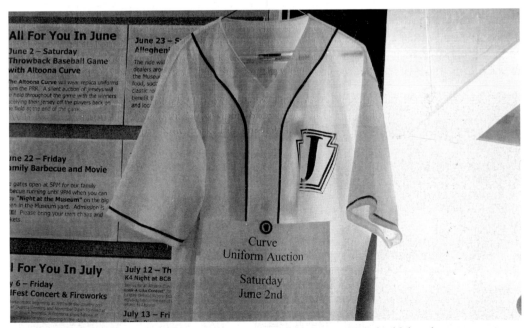

Pictured is a jersey that the Altoona Curve wore in a June 2, 2007, doubleheader sweep against the Reading Phillies. In what has become an annual tradition, the Curve will wear a uniform to honor a classic railroad team, and after the contest, they auction the shirts that the players have worn with the proceeds going to support the Railroaders Memorial Museum.

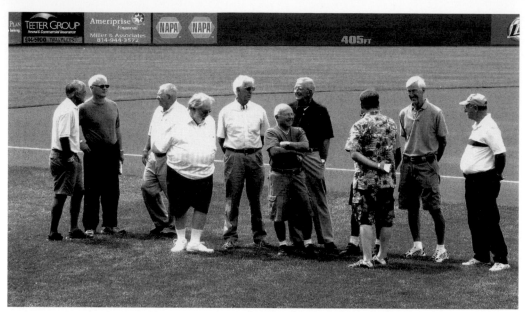

Winning the 1957 National Amateur Baseball Federation Senior Division championship was a team that represented Altoona. Pictured above are members of that club as they are honored at Blair County Ballpark on July 25, 2007, before the Curve-Binghamton game, celebrating the 50th anniversary of their memorable national championship.

The scoreboard at Vets Park was busy in the Altoona Rail Kings' inaugural season in 1996. Even though the club finished at 36-42, it had many good players like second baseman Billy Reed, who hit .329 with a North Atlantic League–high 18 doubles while his double play partner, shortstop Karun Jackson, hit .282.

THE 1999–2001 CURVE

Altoona was a city that had a horrendous track record of hosting professional baseball. Six different teams lasted a total of 14 seasons, and there was no reason to really think that Altoona's new entry in the Eastern League would be more successful.

Nonetheless, Bob Lozinak, Tate DeWeese, and Mark Thomas thought enough of the future of baseball in Altoona that they aggressively pursued one of two Double-A franchises that became available when Major League Baseball decided to expand. After what was thought to be a sure bid for a franchise for Springfield, Massachusetts, fell through, the trio went to the Pennsylvania lawmakers to try to secure financing for a stadium and bring the highest level of professional baseball to the city in 113 years. The Pennsylvania state legislature passed a last-minute, nearly $11 million bill, and the group had its stadium.

The group went to Las Vegas to make its now firm proposal and received a successful, unanimous vote by the minor-league expansion committee. On October 5, 1997, the Altoona Curve were born.

Well, the team was not exactly the Curve from the beginning; the club was also considering names such as Lake Monsters and Ridge Runners, but the Curve celebrated the city's rich railroading heritage and was a perfect fit.

A year after it secured the franchise, the ownership group signed a four-year development agreement with the nearby Pittsburgh Pirates and broke ground on what would be one of the finest facilities in all of minor-league baseball. All that was left was to actually put a team on the field.

On April 10, 1999, that dream came to fruition as the Curve played their first contest, splitting a doubleheader with Reading. Five days later, 6,171 fans christened Blair County Ballpark with a 6-1 thrashing of Bowie.

Despite the fact the club was not very successful on the field its first three seasons, finishing below .500 twice, it was at the gate, averaging almost 5,000 fans per game and showing that the vision of Lozinak, DeWeese, and Thomas was right on the button. The following page outlines the statistics of the first three years in Curve history and lists Altoona natives to play in the major leagues.

Year	Wins	Losses	Percentage	Games behind	Place	Average attendance
1999	63	77	.479	13.0	6th	4,695
2000	74	68	.521	11.0	4th	5,060
2001	63	79	.444	21.0	5th	5,122

Altoona Natives to Play Major-League Baseball

Player	Position	Years played	Teams
John Ake	Third base	1884	Baltimore
Ron Blazier	Pitcher	1996–1997	Philadelphia Phillies
Ripper Collins	First base	1931–1938, 1941	St. Louis, Chicago Cubs, Pittsburgh
John Gochnauer	Shortstop	1901–1903	Brooklyn, Cleveland
Thomas Healy	Third base	1915–1916	Philadelphia Athletics
Tommy Irwin	Shortstop	1938	Cleveland
Pat Malone	Pitcher	1928–1937	Chicago Cubs, New York Yankees

For those who are not quite sure exactly why Altoona's minor-league team is named the Curve, the picture above shows exactly why. The team is named after the national landmark Horseshoe Curve. Horseshoe Curve was the brainchild of J. Edgar Thomson and was opened in 1854 by the PRR as a way to get the railroad around the challenges presented to it by the Allegheny Mountains. Originally it was a two-track layout that was expanded to four between 1898 and 1900 (Conrail removed one in 1981, making it three rails). The curve was deemed so important to the national security that it was not only protected by Union soldiers during the Civil War but was the target of Nazi terrorists in 1942, as the FBI arrested eight Nazi spies who were planning to blow it up. (Courtesy of the Railroaders Memorial Museum.)

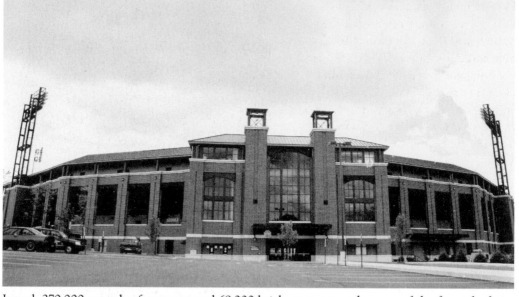

It took 270,000 pounds of concrete and 69,000 bricks to put together one of the finest facilities in minor-league baseball, Blair County Ballpark. Beginning with a jam-packed crowd of 6,171 fans on opening night in 1999, over three million fans have entered these gates to watch Curve baseball over the past nine years. (Courtesy of the Altoona Curve.)

BLAIR COUNTY BALLPARK
1999
DEDICATED TO THE
TAXPAYERS OF THE
STATE OF PENNSYLVANIA

While Bob Lozinak, Tate DeWeese, and Mark Thomas had the finances to buy the franchise, it was not until the Pennsylvania state legislature came through with the $10.8 million to build Blair County Ballpark that the Altoona Curve came to fruition. This plaque honors the taxpayers of Pennsylvania who paid the bill.

Decorating the concourse area of the ballpark are banners celebrating the opening day rosters for each of the Curve's nine ball clubs. In the 1999 home opener, the first game ever at the new facility, Garrett Long and Craig Wilson each cracked a home run as Bronson Arroyo picked up the win in a rain-soaked 6-1 win over Bowie.

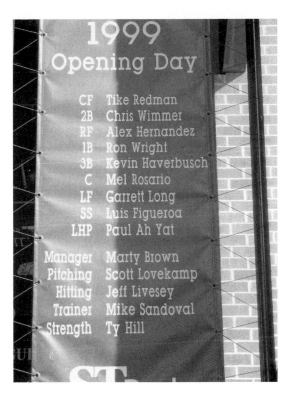

1999
Opening Day

CF Tike Redman
2B Chris Wimmer
RF Alex Hernandez
1B Ron Wright
3B Kevin Haverbusch
C Mel Rosario
LF Garrett Long
SS Luis Figueroa
LHP Paul Ah Yat

Manager Marty Brown
Pitching Scott Lovekamp
Hitting Jeff Livesey
Trainer Mike Sandoval
Strength Ty Hill

A huge green figure rumbles through Blair County Ballpark every night entertaining young and old alike. When one looks more closely, the mascot is a replica of a K4 engine that was built at the PRR in the 1800s and is named Steamer. While the team has added another mascot named Diesel Dawg, Steamer has been there from the beginning and is a big part of the stadium ambiance. (Courtesy of the Altoona Curve.)

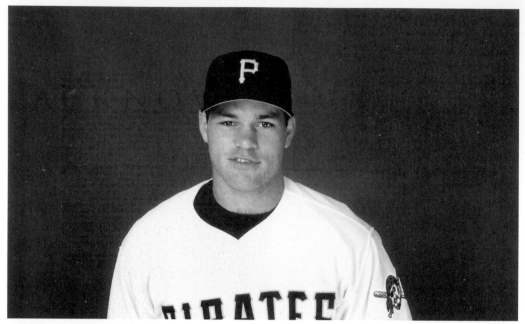

Adam Hyzdu traveled to 11 minor-league cities before he finally lived his dream in the show with the Pittsburgh Pirates in 2000. The former first-round pick of the San Francisco Giants in 1990 eventually found his way to Altoona, where he became a legend. Hyzdu hit 24 homers and 78 RBIs his first year with the Curve before his monster campaign a year later. (Courtesy of the Pittsburgh Pirates.)

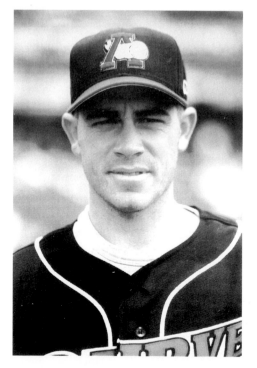

A third-round selection in the 1994 draft by the Pirates, Aaron France had three decent seasons for the Curve. The righty out of Anaheim, California, who led the Bucs organization in ERA in 1998 at Lynchburg, was 10-9 for Altoona between 1999 and 2001. After a decent 5-2 mark in 2000, France had his worst season in the organization in 2001 with a 5.68 ERA. (Courtesy of the Altoona Curve.)

THE 1999–2001 CURVE

The first Curve player ever to get the call to the majors, Yamid Haad was undistinguished with Altoona, hitting .182, but nonetheless was called up on July 5, 1999, after Jason Kendall's horrific ankle injury. He went zero for one before heading back down. Currently in the Cleveland Indians organization, Haad was suspended 50 games with San Francisco in 2006 for testing positive for steroids. (Courtesy of the Pittsburgh Pirates.)

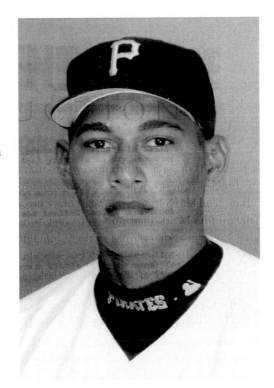

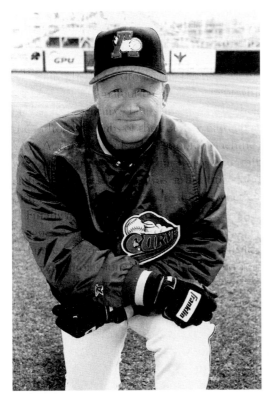

Scott Lovekamp served two terms as pitching coach with the Curve, in 1999 and 2001. Lovekamp began in the Pirates organization in 1994 as a scouting supervisor in both Florida and Georgia before becoming a pitching coach. In his eight-year coaching tenure in the Bucco system, Lovekamp made his rounds through Augusta, Altoona, and Lynchburg. (Courtesy of the Altoona Curve.)

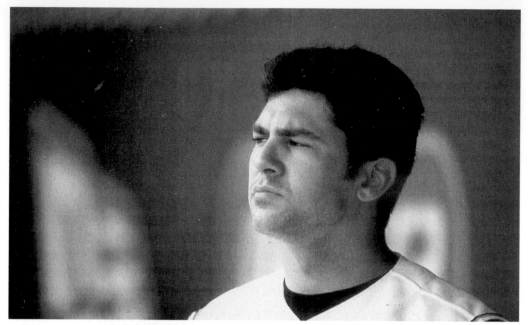

Rob Mackowiak came up to the Bucs in 2001 after two seasons in Altoona, including a banner year in 2000 for the Curve, hitting .297. The 53rd-round pick had the ultimate day on May 28, 2004, against the Chicago Cubs in a doubleheader where he-had a walkoff grand slam in game one and a three-run shot to end game two, all the while celebrating the birth of his son. (Courtesy of the Pittsburgh Pirates.)

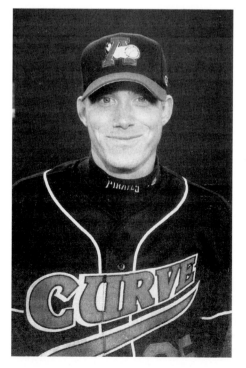

An 11th-round pick out of Cincinnati, Brian O'Connor had a banner year for the Altoona Curve in 2000, finishing with a 12-4 mark and 3.76 ERA. His .750 winning percentage still ranks as the franchise's third-best single-season mark of all time. On the flip side, O'Connor's 202 all-time walks top the team's list in that less-than-stellar category. (Courtesy of the Altoona Curve.)

Although he was an average slap hitter who hit .269 in his lone season in Altoona in 1999, no one could have predicted the speedy center fielder's rapid rise and fall in the majors. Slumping at .224 as a rookie in 2001, Redman had an incredible 2003 with a .330 average. Unfortunately that was the apex of Tike's career as he never reached those lofty heights again. (Courtesy of the Pittsburgh Pirates.)

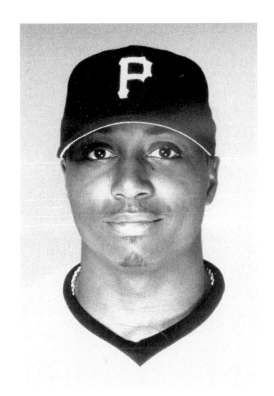

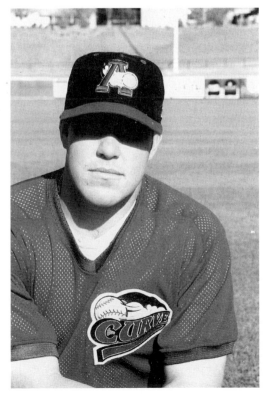

When Ron Wright came to the Bucs in a trade with Atlanta in 1996, he was the centerpiece of the deal, and it was hoped he would bring power back to the Bucs' offense. Back injuries and a broken wrist ruined his dreams, although he did make the show in 2002 with Seattle, becoming only the second player in major-league history to hit into a triple play in his debut. (Courtesy of the Altoona Curve.)

Bronson Arroyo's 1999 campaign with Curve is arguably the greatest single season a pitcher has ever had with the club. He was 15-4 on a team that went 63-77. Arroyo's 15 wins are still the most in Curve history while his .769 winning percentage is second best. Unfortunately for the Pirates, it was not until they released him in 2003 that Arroyo's major-league career took off. (Courtesy of the Pittsburgh Pirates.)

After a less-than-stellar inaugural season, the 2000 version of the Curve would find a little more success. Opening day leadoff hitter Rob Mackowiak would have a very fine campaign with a .297 average, while the number three hitter, Adam Hyzdu, became an Altoona legend with an Eastern League MVP award.

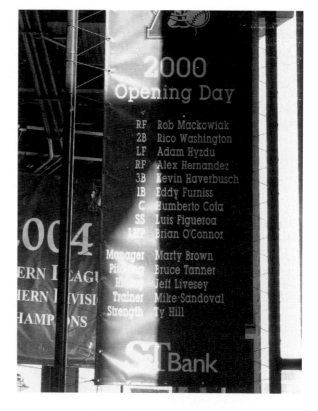

THE 1999–2001 CURVE

While not necessarily a positive thing that he pitched four seasons in Double A with the Curve, Brad Guy is nonetheless one of the best relievers in team history. The 27th pick in the 1997 draft, Guy tossed 116 games for Altoona, all but 10 in relief, while picking up 12 saves. (Courtesy of the Altoona Curve.)

The key ingredient of the Jose Guillen trade to Tampa Bay, where he was one of the Devil Rays' top prospects, was Humberto Cota. The catcher, who was named one of *Baseball America*'s top 10 prospects in the Appalachian League in 1998, had one of his most unspectacular minor-league campaigns with Altoona in 2000, hitting only .261 with eight home runs. (Courtesy of the Pittsburgh Pirates.)

BASEBALL IN ALTOONA

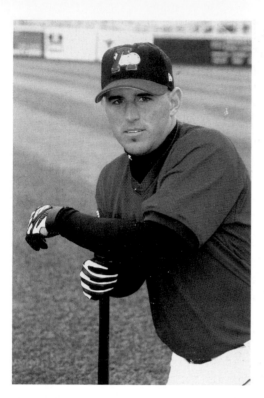

He was a 10-year veteran of the minor-league wars when the Bucs signed Darren Burton as a six-year minor-league free agent in 2000. Taking the step down from Triple-A Scranton to Altoona, Burton had a phenomenal 2000 campaign for the Curve, hitting .328 in 229 at bats. He followed that up with a solid .288 season the year after. (Courtesy of the Altoona Curve.)

Southpaw John Grabow began his career at Altoona in 2000 as a starter, leading the club in starts, innings pitched, and strikeouts. Unfortunately Grabow could not make the next step, laboring in Double A three more years before he went to the bullpen in 2003. It was a fortuitous move for Grabow as he finally made it to the show that year and has stayed there ever since. (Courtesy of the Altoona Curve.)

The first everyday player to graduate from the Curve, Jack Wilson, found himself in Altoona shortly after a trade with the St. Louis Cardinals in 2000 for pitcher Jason Christiansen. Hitting only .252 in 139 at bats, Wilson nonetheless took his magic glove to PNC Park the following season and has been a staple in the Pirates lineup since, becoming an all-star in 2004.

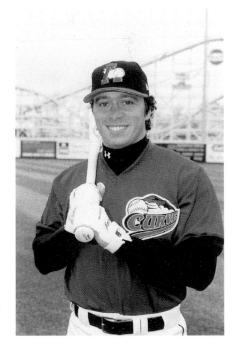

Laboring in the Atlanta Braves system for six seasons before the Bucs signed him as a six-year minor-league free agent in 2000, outfielder Jayson Bass came to Altoona, smacking a triple for his first Curve hit on August 19 against Harrisburg. Bass had a very subpar season in his final year with the club in 2001, hitting only .235 in 170 at bats. (Courtesy of the Altoona Curve.)

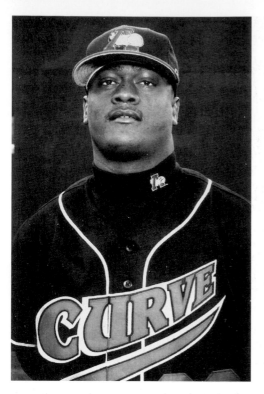

His first game for Altoona in 2000 after coming over from San Diego in the Al Martin trade was not indicative of what was to come for Geraldo Padua. Padua gave up one hit in seven innings against Erie. He ended the season 1-6 before sporting a 9.69 ERA in 2001. During that year, Padua flipped off fans after a poor outing against Akron and was released the next day. (Courtesy of the Altoona Curve.)

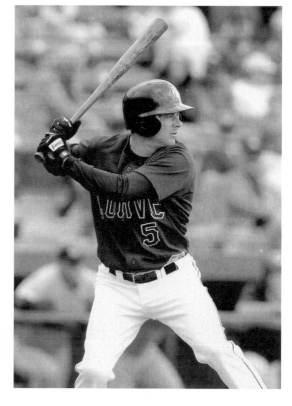

While staying in Double-A ball for five years is generally not conducive to one living his dream as a major-league baseball player, Shaun Skrehot nonetheless became the leader in many Altoona Curve offensive categories. The University of Houston alumnus played more games, scored more runs, had more hits, and smacked more doubles than any Curve player in the franchise's nine-year history. (Courtesy of the Altoona Curve.)

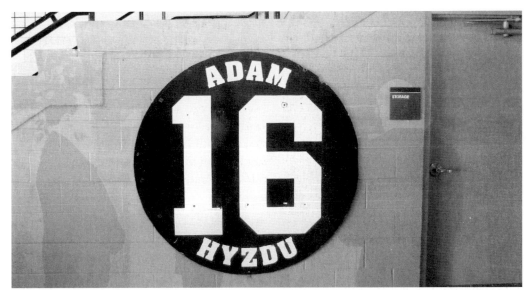

His 2000 campaign is legendary among Altoona baseball aficionados. Mention the greatest player in franchise history, and the argument begins and ends with Adam Hyzdu. After a 24–home run season in the Curve's inaugural year, Hyzdu made an unexpected trip back to Altoona in 2000 and made sure it was memorable. The San Jose native smacked 31 home runs with 106 RBIs, capturing the Eastern League MVP. In the photograph above is the sign that hangs at Blair County Ballpark and marks the ultimate honor the franchise bestowed upon him, retiring his No. 16. Below is a card Curve fans signed for Hyzdu when he finally lived his dream and was called up to the majors on September 8. (Below, courtesy of the Altoona Curve.)

BASEBALL IN ALTOONA

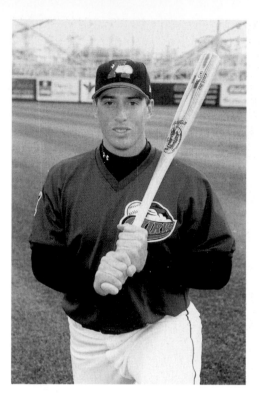

A 42nd-round pick in the 1998 draft for the Bucs, Derrick Lankford had a very solid season for Altoona in 2000. The first baseman/outfielder hit .293 with 10 home runs after smacking 52 long balls in the previous three campaigns in the Pirates organization. The year 2000 would be the high point for Lankford as he went 3 for 19 in his final year in a Curve uniform. (Courtesy of the Altoona Curve.)

Pittsburgh drafted Cranberry's Joe Beimel in the 18th round after he spent a year at nearby Duquesne University. While spending an unspectacular season in Altoona in 2000 with a 1-6 mark, Beimel nonetheless made the big jump in 2001, bypassing Triple A to go straight to the majors. The southpaw spent three years in Pittsburgh and currently is in the Los Angeles Dodgers bullpen. (Courtesy of the Altoona Curve.)

Perusing the opening day roster for the Altoona Curve, one sees very quickly why they dropped 11 games versus their 2000 season output: they had few major-league prospects. Other than starting pitcher John Grabow, who later became more effective as a lefty reliever, no one in the lineup ever made a major contribution to the Bucs. (Courtesy of the Altoona Curve.)

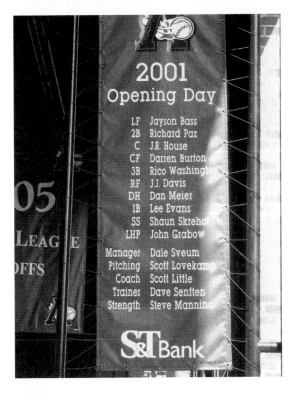

2001
Opening Day

LF	Jayson Bass
2B	Richard Paz
C	J.R. House
CF	Darren Burton
3B	Rico Washington
RF	J.J. Davis
DH	Dan Meier
1B	Lee Evans
SS	Shaun Skrehot
LHP	John Grabow
Manager	Dale Sveum
Pitching	Scott Lovekamp
Coach	Scott Little
Trainer	Dave Senften
Strength	Steve Manning

S&T Bank

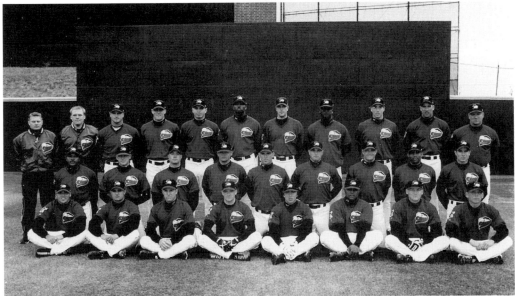

Following a fine season where they finished only one and a half games out of a playoff spot, the 2001 Altoona Curve tumbled down the Southern Division standings of the Eastern League, being saved of a last-place finish only by the ineptitude of the Bowie Baysox. There were no award winners and no all-star picks, and only Chris Spurling's 3.11 ERA made a dent in the league leaders. (Courtesy of the Altoona Curve.)

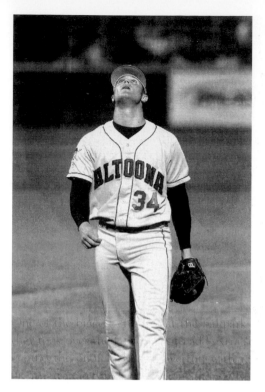

Like John Grabow, Jeff Bennett's major-league aspirations took a turn upward when he made the move from the starting rotation to the bullpen. Bennett had a solid season in the Curve's 2003 pen with a 2.72 ERA and became a casualty soon after when the Milwaukee Brewers picked him in the Rule 5 draft. Bennett stayed with Milwaukee in 2004 but unfortunately underwent Tommy John surgery two years later. (Courtesy of the Altoona Curve.)

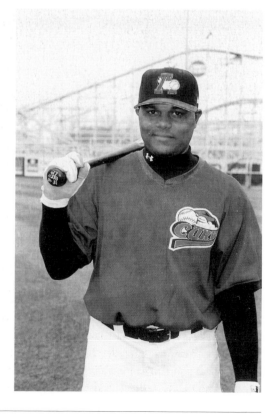

A man who had the golden touch at first base, Carlos Rivera also turned out to be one of the best power hitters in franchise history. Named by *Baseball America* as the Eastern League's best defensive first baseman, Rivera showed he had power in his bat in 2002 after a subpar 2001 campaign, smacking 22 homers with 84 RBIs while cracking the .300 mark at .302. (Courtesy of the Altoona Curve.)

Chris Peterson had a very short and unspectacular stay in Altoona in 2001. Only appearing in 38 games, coming up 100 times, Peterson batted a mere .210 with no home runs, not exactly the type of year that would garner Peterson Adam Hyzdu–type reverence in Altoona. (Courtesy of the Altoona Curve.)

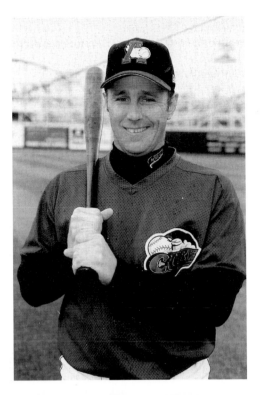

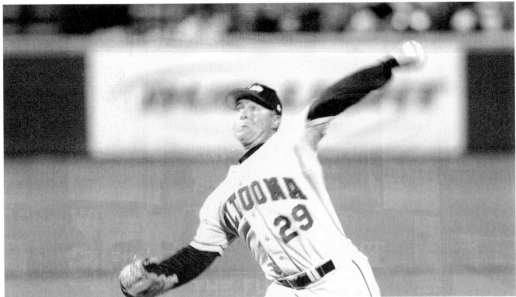

Picked up in the minor-league Rule 5 draft from the Seattle organization, Clint Chrysler spent three years in Altoona, becoming one of the best relief pitchers in team history. A Stetson University alumnus, Chrysler had a fine campaign in Lynchburg, 5-1-2.57 ERA, before being promoted to the Curve in 2001. The lefty appeared in 118 career games in Altoona, second on the all-time list. (Courtesy of the Altoona Curve.)

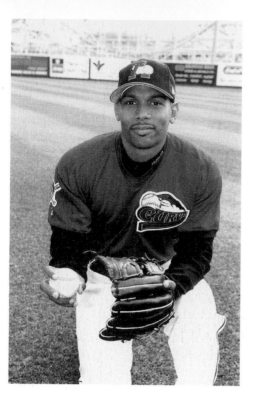

A Philadelphia native, Bo Donaldson spent his professional baseball career bouncing around from one minor-league city to another. A former 19th-round pick by the Anaheim Angels in 1997, Donaldson found his way to Altoona in 2001 and became the team's closer. He went 5-1 in 17 appearances with five saves and a 3.10 ERA, earning him a promotion to Triple-A Nashville before the season's end. (Courtesy of the Altoona Curve.)

Spending parts of three seasons in Altoona, catcher/outfielder Ryan Doumit showed glimpses of potential in his nine years of minor-league ball, but injuries have hampered his progress. In his only full season with the Curve in 2004, soreness in his right elbow ended his year at the halfway point. After hitting .415 to begin 2007 with Indianapolis, Doumit was recalled to Pittsburgh, where he will hopefully fulfill his potential. (Courtesy of the Altoona Curve.)

After compiling an 18-25 career record in Altoona as a starter for three years, lefty John Grabow made the switch to the bullpen in 2003. That campaign made the Pirates organization really stand up and take notice when he went to the bullpen and finished 6-1 with only 19 walks in 83 innings of work. By the end of the year, his dream became reality when the Bucs recalled him on September 13. (Courtesy of the Altoona Curve.)

Following a monster minor-league year in 2000 where he hit 23 homers with a .348 average, J. R. House kept Pirates management guessing whether he would play baseball or accept a football scholarship to West Virginia University. The former high school quarterback great chose baseball, but unfortunately his once promising career was hindered by, among other things, abdominal and elbow injuries he suffered in 2002 with the Curve.

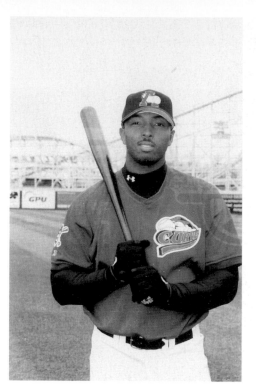

Turning down a basketball and football scholarship at the University of Southern California and Oregon State University, respectively, J. J. Davis signed with the Pirates after being selected sixth overall in the 1997. At Altoona, Davis's best season came in 2002 when he 20 homers with a .287 average. He never made a dent in the majors, however, hitting only .179 in 106 at bats. (Courtesy of the Altoona Curve.)

Showing potential as a power hitter with High Desert in the Diamondbacks' system with 24 homers in 1999, Dan Meier was picked up by the Bucs in a minor-league deal with Arizona. While showing a little pop with the Curve in 2001 with 13 homers, Meier never reached his 1999 power numbers again. He signed with Amarillo of the Central League in 2003 and played four seasons of independent league baseball. (Courtesy of the Altoona Curve.)

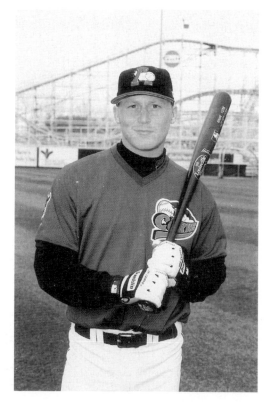

THE 1999–2001 CURVE

In the history of the Curve no one has come close to pitching as many games as Neal McDade. The 29th-round pick pitched in 138 contests, 20 more then the next highest pitcher. Shelved the entire 1999 campaign when he had Tommy John surgery, McDade was part of history in 2002, when he was one of three pitchers who combined to hurl the team's only no-hitter against Akron. (Courtesy of the Altoona Curve.)

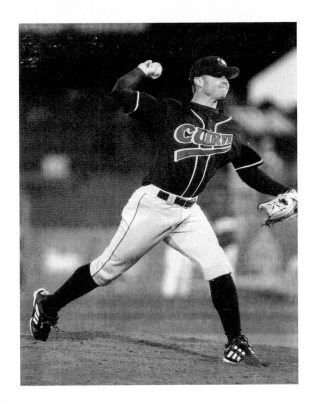

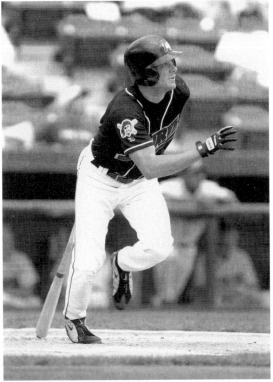

As the most tenured player in Curve history, playing in 410 games, Shaun Skrehot was at his best in 2001. Hitting .267 with a career high six homers and 24 stolen bases, Skrehot was named the team's MVP. Injuries would stall the Houston native's progress as he suffered a broken finger, bad back, and severely pulled groin. (Courtesy of the Altoona Curve.)

A 12-year major-league veteran, utility man Dale Sveum took over the reigns of the Curve in 2001 after finishing his playing career with the Pirates. After a subpar first year, Sveum guided the club to two campaigns over .500, including leading Altoona to its first-ever postseason excursion in 2003. (Courtesy of the Altoona Curve.)

One of only nine players in major-league history who came from the great state of Alaska, Dave Williams announced his presence in a big way in 1999 with Hickory and Lynchburg, leading the entire minor leagues with 201 strikeouts. In the lefty's only season in Altoona, he was impressive, going 5-2 with a sharp 2.61 ERA in 2001. By the end of the year, Williams was in Pittsburgh. (Courtesy of the Altoona Curve.)

THE 2002 AND 2003 CURVE

While a professional team from Altoona was finally enjoying success at the gate as the Curve did in its first three years, it was having a tumultuous time in the front office. The joy of bringing a franchise to this city by owners Tate DeWeese and Bob Lozinak had deteriorated into a nasty three-year war. Squabbles had led the two to federal court, and it was becoming ever so apparent that the relationship could no longer exist . . . enter Chuck Greenberg.

Greenberg is a sports attorney from Pittsburgh who helped put together the purchase of the Pittsburgh Penguins by hockey legend Mario Lemieux. It was the Penguin hall of famer along with Steeler hero Jerome Bettis who joined Greenberg's band of 21 investors, a group that included DeWeese, to take over the Curve operation shortly before the 2002 campaign.

The ownership group, aptly named Curve Baseball LP, was the tonic the franchise needed. With conflicts now a thing of the past, the franchise was set to go forward and began with some major changes to Blair County Ballpark. Before the 2003 campaign, seats were added over the left field wall as well as an expanded picnic pavilion and a section called the Rail Kings where fans were treated to many amenities.

While stadium enhancements were fine, making the on-the-field product more exciting was pivotal to fill the stadium. Finishing below .500 in two of their first three seasons, the Curve concluded 2002 with a decent 72-69 mark; it would be the last year the franchise would miss the Eastern League playoffs.

Led by a solid pitching corps that included Sean Burnett, John Van Benschoten, Mike Johnston, and closer Todd Ozias, Altoona finished in second place, qualifying the team for its first postseason spot. Future Pirate Sean Burnett was particularly impressive with a circuit-high 14 wins, while Ozias was runner-up in saves, collecting a then Curve record 21.

Despite the fact the club lost its first-ever playoff series to Akron 3-1, the groundwork was set for the incredible success the franchise has enjoyed ever since. The team's 2002 and 2003 records and all-time leaders in batting and pitching are listed on the following page.

Year	Wins	Losses	Percentage	Games behind	Place	Average attendance
2002	72	69	.511	21.0	4th	5,273
2003	78	63	.553	10.0	2nd*	5,621

*defeated by Akron 3-1 in the Eastern League Divisional Series (best of five)

All-Time Altoona Curve Batting Leaders

	Career	Single season
Home runs:	Josh Bonifay (55)	Adam Hyzdu (31, 2000)
RBIs:	Josh Bonifay (209)	Adam Hyzdu (106, 2000)
Hits:	Shaun Skrehot (384)	Nate McClouth (166, 2004)
Doubles:	Shaun Skrehot (76)	Nate McClouth (40, 2004)
Triples:	Vic Buttler (15)	Vic Buttler (14, 2006)
Strikeouts:	Josh Bonifay (312)	Simon Pond (121, 2006)
Games played:	Shaun Skrehot (410)	Adam Hyzdu (142, 2000)
Runs scored:	Shaun Skrehot (189)	Adam Hyzdu (96, 2000)
Stolen bases:	Chris Duffy (66)	Rajai Davis (45, 2005)
Extra-base hits:	Josh Bonifay 126	Adam Hyzdu (76, 2000)
Batting average:		Jeff Keppinger: (334, 2004)

All-Time Altoona Curve Pitching Leaders

	Career	Single season
Wins:	Landon Jacobsen (30)	Bronson Arroyo (15, 1999)
Losses:	Mike Connolly (29)	John Grabow (13, 2002)
Saves:	Matt Peterson (29)	Matt Peterson (29, 2007)
Games pitched:	Neal McDade (138)	David Daniels (55, 1999)
Games started:	Mike Connolly (83)	Five tied with 27: Brian O'Connor (1999), John Grabow (2002), Landon Hacobsen (2003), Sean Burnett (2003), Josh Shortslof (2007)
Complete games:	Brian O'Connor (6)	Brian O'Connor (4, 2000)
Shutouts:	Ian Snell (2)	Ian Snell (2, 2000), Steve Sparks (2, 2004)
Strikeouts:	Mike Connolly (340)	Ian Snell (142, 2004)
Walks:	Brian O'Connor (203)	Brian O'Connor (92, 1999)
Home runs allowed:	Mike Connolly (42)	Justin Reed (21, 2002)
ERA:		Shane Youman (1.51, 2006)

Coming off the worst season in the team's short history, Altoona came out of the blocks in 2002 looking to rebound from its dismal performance. With a new owner and new enthusiasm, the club overcame a dismal pitching performance, a staff that posted what is still today the highest ERA in the annals of Curve baseball at 4.19, to get on the plus side of .500 at 72-69.

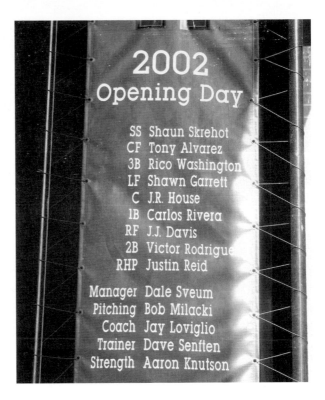

2002 Opening Day

SS Shaun Skrehot
CF Tony Alvarez
3B Rico Washington
LF Shawn Garrett
C J.R. House
1B Carlos Rivera
RF J.J. Davis
2B Victor Rodrigue
RHP Justin Reid

Manager Dale Sveum
Pitching Bob Milacki
Coach Jay Loviglio
Trainer Dave Senften
Strength Aaron Knutson

Sports attorney Chuck Greenberg, who became the new team president and managing partner in 2002, addresses an excited Curve crowd as the team begins the new campaign. Greenberg, who leads the sports practice department and is a partner in the prestigious law firm Pepper Hamilton, LLP, put together a group of investors, Curve Baseball LP, that purchased the club from former owners Bob Lozinak and Tate DeWeese. (Courtesy of the Altoona Curve.)

Before the home opener against Harrisburg, members of both teams roll out the flag to honor America. It was the first contest Altoona played since the tragic events of September 11, 2001. A then record crowd of 6,408 fans crowded Blair County Ballpark to see Altoona beat the Senators 7-5. (Courtesy of the Altoona Curve.)

Altoona slugger J. J. Davis had a phenomenal season for the club in 2002. The Pirates' first-round pick in 1997, Davis smacked 20 homers while hitting .287 and finishing third in the Eastern League in slugging with a .526 mark. The Charlotte native also had a team-record 27-game hitting streak and was named the league's Player of the Week for his .448 performance the week of July 28. (Courtesy of the Altoona Curve.)

THE 2002 AND 2003 CURVE

Rolling into Blair County Ballpark on opening night in 2002 is a school bus carrying one of the greatest running backs in NFL history, "the Bus" himself, Jerome Bettis. Bettis, who was one of the investors in the Curve Baseball LP group that purchased the club prior to the season, is one of the greatest icons in Pittsburgh sports history. The Notre Dame alumnus proved that big men can make great running backs too. The Bus rambled for 13,662 yards over his 13-year career, which is the fifth-best mark in the annals of the NFL. The Pro Bowler and likely future hall of famer ended his phenomenal career in storybook fashion by leading the Steelers to their fifth Super Bowl title in his hometown of Detroit. (Courtesy of the Altoona Curve.)

Coming to Pittsburgh from San Diego in the Emil Brown trade, switch-hitter Shawn Garrett became one of the best players in Curve history. The two-time Eastern League all-star had a very fine all-around first season in an Altoona uniform, hitting .290 with 11 homers and 19 stolen bases. (Courtesy of the Altoona Curve.)

Throwing out the first pitch at an 11:05 morning tilt against Norwich on May 30 was the legendary Pittsburgh Steelers coach Bill Cowher. Cowher, who retired following the 2006 campaign, was one of the greatest coaches in the history of the game. With a 149-90-1 regular-season mark, Cowher led the club to 10 postseason appearances in 15 years and the Super Bowl XL championship. (Courtesy of the Altoona Curve.)

A right-handed hurler who was acquired by the Pirates from Cincinnati in the Jose Silva deal, Ben Shaffar had his fine 2002 campaign end on July 26 in Erie. Owning one of the best split-fingered fastballs in the organization, Shaffar was sporting an 8-7 mark as he took a shutout into the ninth inning when he ruptured his patella tendon in the right knee while fielding a grounder. (Courtesy of the Altoona Curve.)

Picked up in 2002 by Pittsburgh after a stint in the independent leagues, middle infielder Joe Caruso may not have had a stellar career with the Curve, but he did achieve something in professional baseball that few achieve. In 2001, Caruso played all nine positions in one game while in the Royals organization with Wichita. (Courtesy of the Altoona Curve.)

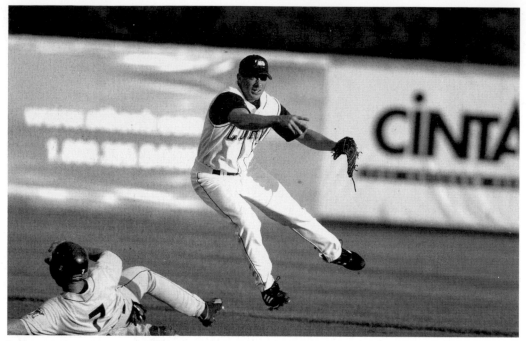

Following his team MVP performance in 2001, Shawn Skrehot could not recapture the magic, having a very subpar 2002 campaign. A bad groin injury limited the team's all-time career-hit leader to only 312 at bats as the former 38th-round draft pick's average tumbled 27 points to .240. (Courtesy of the Altoona Curve.)

While Shawn Garret was never considered a top-notch prospect, Pirates director of player development Brian Graham still had hopes. Graham is quoted as saying on Scouts.com, "I think what people don't understand is that prospects, a lot of the time, are evaluated based on one tool or skill. But the ability to perform is what makes Shawn Garrett a prospect." Garrett is currently in the Cardinals organization. (Courtesy of the Altoona Curve.)

With the beginning of the 2003 campaign came the start of a new era of Altoona Curve baseball, one that would see them a fixture in the Eastern League postseason. The club improved six games in the second season of the Chuck Greenberg regime, finishing in second place behind the Akron Aeros. Unfortunately the Curve would be beaten handily in the best-of-five series, being outscored 30-12.

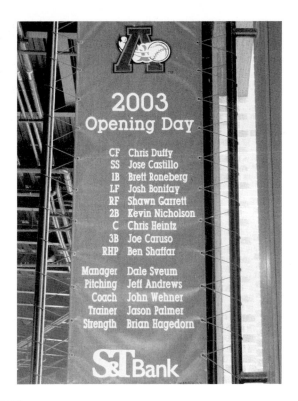

2003
Opening Day

CF	Chris Duffy
SS	Jose Castillo
1B	Brett Roneberg
LF	Josh Bonifay
RF	Shawn Garrett
2B	Kevin Nicholson
C	Chris Heintz
3B	Joe Caruso
RHP	Ben Shaffar
Manager	Dale Sveum
Pitching	Jeff Andrews
Coach	John Wehner
Trainer	Jason Palmer
Strength	Brian Hagedorn

S&T Bank

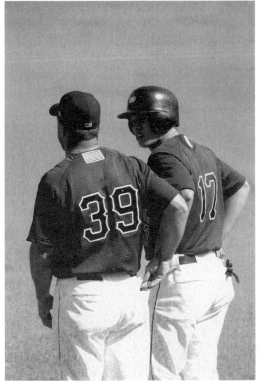

One of the rare professional baseball players to come from the land down under, Brett Roneberg (No. 17) came to the Curve as a minor-league free agent in 2002. The Melbourne native, who played for his country in the 2000 Sydney Olympics, had a very solid season in his inaugural Curve campaign, hitting .281 with 10 homers. (Courtesy of the Altoona Curve.)

After his first-round selection by the Pirates in 1999, lefty Sean Burnett had nothing but success before he found his way to Altoona in 2003. Burnett fortunately continued to excel as he had the best year a pitcher ever had for the franchise, with a 14-6 mark while being named the Eastern League's Pitcher of the Year. (Courtesy of the Altoona Curve.)

Pitching in parts of four seasons for the Curve, Landon Jacobsen has the honor of being the all-time winningest pitcher in club history with 30 victories. Sporting a 30-22 mark in his Altoona career, Jacobsen got off to a great start in his inaugural Curve campaign in 2003, setting a club record for innings pitched with 162 2/3 while finishing second in the circuit with a 2.93 ERA. (Courtesy of the Altoona Curve.)

Curve fans were excited when the Bucs' No. 1 pick in the 2001 draft, John Van Benschoten, was on the Altoona roster in 2003. A Kent State alumnus, Van Benschoten was a unique mix coming out of college. He not only was a fine pitcher but was a phenomenal hitter, leading the nation with 31 homers and 84 RBIs in 2001. (Courtesy of the Altoona Curve.)

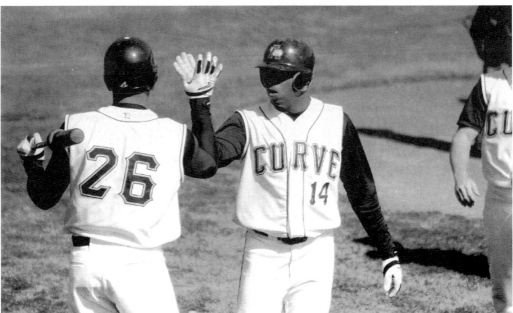

In a shot of what would become a future picture in PNC Park, second baseman Jose Castillo (No. 14) and catcher Ronny Paulino (No. 26) celebrate at home plate. Castillo and Paulino were together with the Curve in 2003. While Castillo impressed the major-league scouts with his .287 average and athleticism, Paulino struggled, only hitting .226. (Courtesy of the Altoona Curve.)

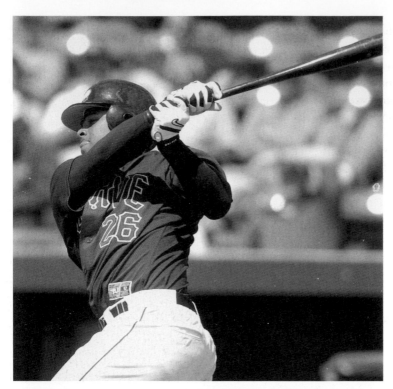

While not starting off particularly sharp with Altoona in 2003, Ronny Paulino eventually would show his stuff to the Pirates as he flashed some power in 2004 and smacked 15 homers in 99 games with a .285 average. For his efforts, Paulino was named to the Eastern League's postseason all-star team. (Courtesy of the Altoona Curve.)

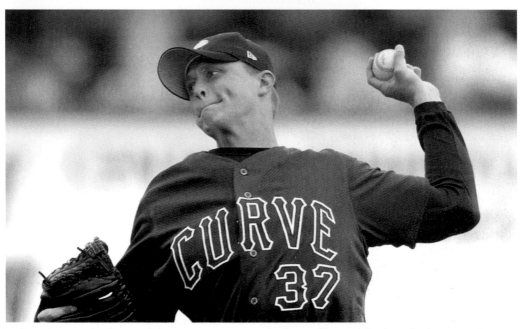

Mike Johnston had one of the greatest seasons a reliever has ever had in the history of Curve baseball in 2003. With a 6-2 mark and a 2.12 ERA, Johnston was absolutely remarkable. The Philadelphia native stifled Eastern League hitters, surrendering only 49 hits in 72 innings while being selected as an all-star. (Courtesy of the Altoona Curve.)

In the 21st century, the powers that be with the Pirates have put a premium on pitching as the club has picked pitchers first, six times in the past eight years. Surprisingly it was a 26th-round choice that has become the best of them all, Ian Snell. In mid-2003, Snell was promoted from Lynchburg to Altoona, where he was 4-0 and was named the organization's Minor League Pitcher of the Year. (Courtesy of the Altoona Curve.)

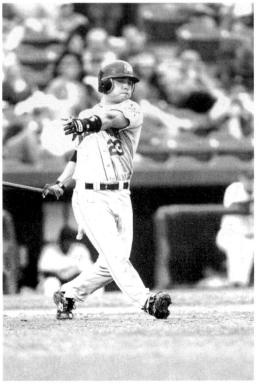

Having the distinction as the first Canadian ever drafted in the first round when the San Diego Padres picked him in 1997, Kevin Nicholson was inked by the Pirates after the 2002 campaign. The switch-hitter led the Curve with a .294 average in 2003 but is more known for hitting one of the greatest homers in team history, clubbing the game winner in the second game of the 2003 series against Akron. (Courtesy of the Altoona Curve.)

Southpaw Mike Connolly is at the top of the Curve all-time lists in many categories, both good and unfortunately bad. Connolly not only is second in career wins with 27 but tops the all-time loss list at 29 in his four Curve seasons. In 2003, Connolly had his best season in Altoona, going 7-8 with an Eastern League eighth-best 3.39 ERA. (Courtesy of the Altoona Curve.)

A 19th-round pick from Wayne State College, where he was the school's all-time leader in wins with 30 victories, Brady Borner became the first hurler from the 2001 draft class to be promoted to Altoona in 2003. Borner was at his best in 2005 when he was 6-1 in 48 appearances with a 2.08 ERA, the team's third-lowest mark ever. (Courtesy of the Altoona Curve.)

The winningest pitcher in Altoona history, Landon Jacobsen was with the club for four seasons. After a fine 2003 campaign, Jacobsen developed tendonitis in his right shoulder, eventually having it operated on, which ended his 2004 season. It was tale of two seasons, as short as it was, starting out 1-2 with a 7.20 ERA before winning his last four decisions with a microscopic 2.08 ERA before the injury. (Courtesy of the Altoona Curve.)

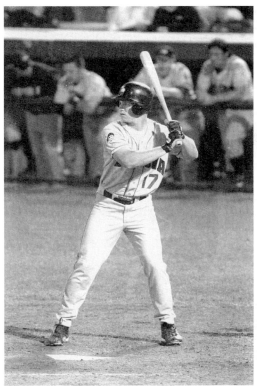

A pivotal member of the Curve for the last couple seasons, Brett Roneberg has been a star in international play for his home country, Australia. During the 2000 Olympics in Sydney, Roneberg led his home country to a surprising silver-medal finish. Roneberg, who hit .361 with three homers and seven RBIs during the Games, also played for Australia in the inaugural World Baseball Classic in 2006. (Courtesy of the Altoona Curve.)

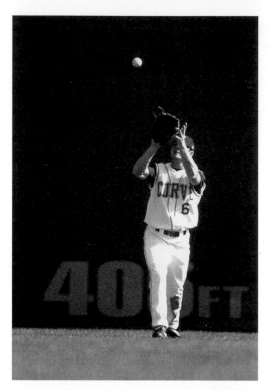

A speedy defense center fielder who has given the Bucs their best defensive presence at the position since the days of Andy Van Slyke was also one of the greatest stolen-base threats in Altoona history. Hitting .273 and .309, respectively, for the Curve in 2003 and 2004, Chris Duffy was a terror on the base paths, swiping an Altoona career record 66 bases in his two seasons. (Courtesy of the Altoona Curve.)

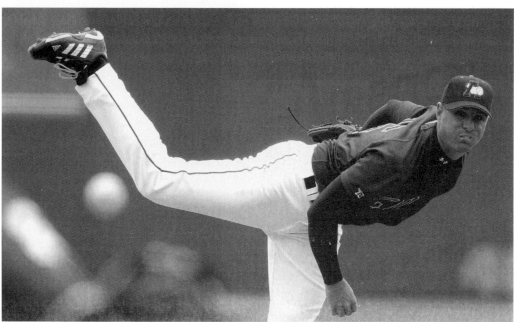

Signed as a minor-league free agent before the 2003 campaign from the Cincinnati Reds organization, Todd Ozias gave the Curve the reliable stopper they were looking for. The closer, who was once part of the Andres Galarraga trade between Texas and San Francisco, saved a then team record 21 games with a miniscule 1.62 ERA. (Courtesy of the Altoona Curve.)

THE 2002 AND 2003 CURVE

In a system that was once full of catchers like Jason Kendall, J. R. House, and Ryan Doumit, little-known Ronny Paulino was expendable in 2003. The Pirates left him unprotected in the Rule 5 draft, and the Kansas City Royals snapped him up. Fortunately for the powers that be in the Bucco organization, the Royals returned Paulino in March 2003. (Courtesy of the Altoona Curve.)

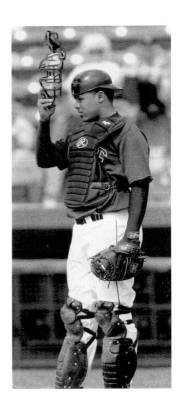

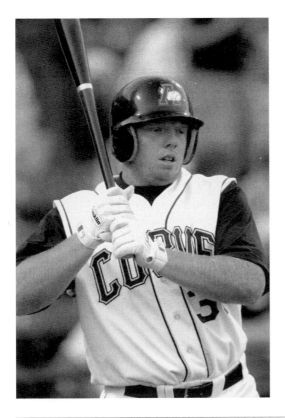

Winner of the Mountain West Conference Player of the Year when he was with the University of Utah in 2001, Chris Shelton took the Pirates organization by storm, hitting .340 in his first three seasons of Class-A ball. After smacking 21 homers with a .359 average in 95 games for Lynchburg, Shelton was promoted to Altoona, where the slugger went homerless in 35 games. (Courtesy of the Altoona Curve.)

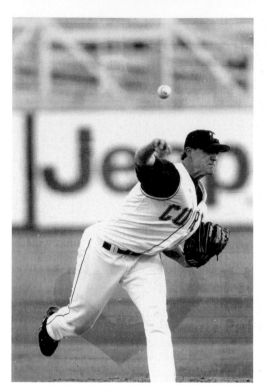

Following his somewhat successful stint with Altoona, John Van Benschoten was promoted to Triple-A Nashville in 2004. The former first-rounder had a miserable year with the Sounds at 4-11 but nonetheless found his way to PNC Park by the season's end. Unfortunately for Van Benschoten, he hurt his right shoulder and had season-ending surgery. After almost two years of recovery, Van Benschoten finally reached the majors again in 2007. (Courtesy of the Altoona Curve.)

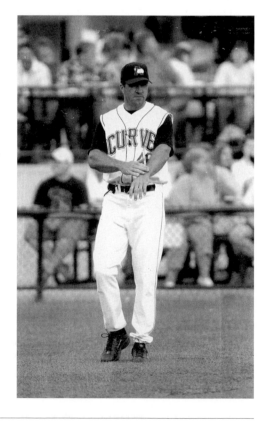

Former major-league utility man John Wehner joined the Curve as a bench coach in 2003. While never a regular, the Pittsburgh native nonetheless had an eventful 11-year career. In 2000, Wehner hit the final home run ever at Three Rivers Stadium on October 1. That day, Wehner also ended an impressive streak: he made an error at third, his first since 1992, a major-league record 99 consecutive games. (Courtesy of the Altoona Curve.)

THE 2002 AND 2003 CURVE

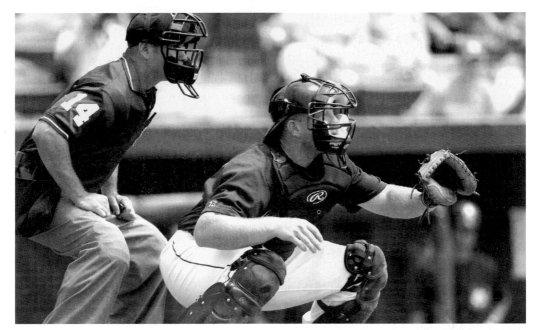

A funny thing happened after catcher Chris Shelton hit .332 during his rapid ascension through the Pirates' farm system: they did not protect him in the 2003 Rule 5 draft. Unfortunately the Detroit Tigers picked up the former Pirate minor-league Player of the Year, and Shelton set the league on its ear in April 2006 when he hit nine homers in Detroit's first 13 games. (Courtesy of the Altoona Curve.)

He may have been low on the organization's depth chart at one point, but by 2005, Ronny Paulino was rapidly rising through the system. Paulino was not only flashing some offensive skills at Indianapolis, but he was named the organization's best defensive catcher by *Baseball America*. In 2006, he showed he could do it at the major-league level by hitting .310 in his rookie season for the Bucs. (Courtesy of the Altoona Curve.)

Starting out the season at shortstop, Jose Castillo moved over to second base for the first time since 1999 after playing at short for 409 consecutive games in the Pirates organization. It was a fortuitous move. The Venezuelan not only made the Eastern League's all-star team but was selected to play in the major league's Futures Game. Castillo would make the jump from Double-A ball to the Bucs in 2004. (Courtesy of the Altoona Curve.)

The son of former Pirates general manager Cam Bonifay came to the Altoona Curve after a monster season in Lynchburg in 2002, where the University of North Carolina–Wilmington alumnus hit 26 homers and knocked in 102. Josh Bonifay continued to excel in Altoona with a .285 average and 11 long balls, 10 of which were on the road. He went on to top the all-time Curve charts in homers, RBIs, and extra-base hits. (Courtesy of the Altoona Curve.)

While lefty Mike Connolly was no more than a .500 pitcher with the Curve, never finishing more than one game under or one game over .500 in his four years in Altoona, his brother Jon, a hurler in the Tigers and Cubs systems, was. Jon was 44-21 in his six-year minor-league career, including an incredible 16-3 mark in 2003 where he had a miniscule 1.41 ERA. (Courtesy of the Altoona Curve.)

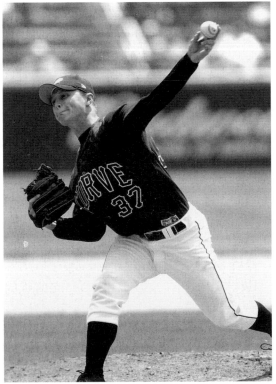

Even though Mike Johnston had a phenomenal season in Altoona in 2003 and made the big jump to the majors with the Pirates the following year, his play on the field was not his most impressive feat. Johnston's biggest accomplishment is the fact he did all that while suffering from Tourette's syndrome, only the second known player to make it to the majors with that disorder. (Courtesy of the Altoona Curve.)

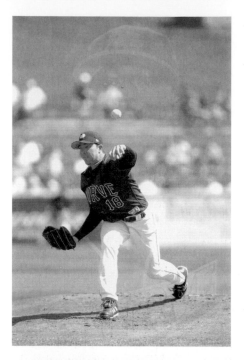

Sean Burnett's future seemed limitless following his record-setting campaign with the Curve. The organization's Pitcher of the Year in 2001 and 2002 was 40-19 at that point, and most thought he would be a star in the majors before too long. Unfortunately, after making it to the Bucs in 2004, the dream was put on hold as Burnett had Tommy John surgery on his left elbow. (Courtesy of the Altoona Curve.)

This banner hangs in the upper concourse in Blair County Ballpark, celebrating the Curve's first-ever postseason experience. Altoona faced off against the Akron Aeros in the first round of the playoffs. After the teams split the first two contests in the best-of-five series in Akron, 7,097 fans packed Blair County Ballpark in Game 3. Unfortunately Akron took both games in Altoona, taking the series 3-1.

THE 2004 AND 2005 CURVE

In the 123 years since the Mountain City became the first professional baseball team in Altoona, no professional club had won a championship over a full season. Yes, the Rail Kings captured the first-half North Division title in 1997, but they failed miserably in the second half, finishing 36-36, so there had been no full-season championships. That all ended in 2004 when the Altoona Curve enjoyed their greatest season in the history of the franchise and secured the Southern Division crown.

With an 85-56 record in hand, the only time the Curve has ever topped the .600 plateau for a season, new manager Tony Beasley led his troops against the Erie Seawolves in the first round of the Eastern League divisional playoffs. Hoping to not have a replay of the 2003 playoff debacle, the club opened the series at Blair County Ballpark with its ace Zach Duke on the mound. Duke was promoted to the Curve during the season and had been lights out with a 5-1 mark and 1.58 ERA. He led a stifling pitching staff that included Ian Snell and Bryan Bullington.

Pitching was not the only attribute this team had. It could score runs too, a team-record 697 to be exact. It could also park some balls over the fence with sluggers such as Brad Eldred (who smacked 17 homers in 39 games), Josh Bonifay, and Ray Sadler.

Without a victory against the Seawolves, all the success of 2004 would go down the drain. The Curve proved quickly, though that this would not be 2003 as they dissected Erie quickly, sweeping them by a combined 36-9 score to advance to the championship series. There the New Hampshire Fisher Cats would unfortunately sweep them in three exciting, close games, but they nonetheless had a wonderful, thrilling season.

The following year, Altoona smashed a team-record 141 homers and qualified for its third consecutive postseason spot. While the team fell to archrival Akron once again in the first round, this time in the maximum five games, it proved in 2004 and 2005 that it was now truly an Eastern League powerhouse. The following pages lists the Curve statistics for the 2004 and 2005 seasons as well as the all-time Altoona Curve all-star team.

Year	Wins	Losses	Percentage	Games behind	Place	Average attendance
2004	85	56	.603	+5.5	1st*	5,621
2005	76	66	.535	8.0	2nd**	5,970

*defeated Erie 3-0 in the Eastern League Divisional Series (best of five) and defeated by New Hampshire 3-0 in the Eastern League Championship Series (best of five

**defeated 3-2 by Akron in the Eastern League Divisional Series (best of five)

The All-Time Altoona Curve All-Star Team
Brad Eldred (first base)
Jeff Keppinger (second base)
Shaun Skrehot (shortstop)
Jose Bautista (third base)
Adam Hyzdu (outfield)
J. J. Davis (outfield)
Tony Alvarez (outfield)
Ronny Paulino (catcher)
Landon Jacobsen (right-handed starter)
Ian Snell (right-handed starter)
Sean Burnett (left-handed starter)
Shane Youman (left-handed starter)
Mike Johnston (middle reliever)
Matt Peterson (closer)

It all started with a four-game winning streak to begin the season and ended five months later with a 13-8 shellacking at the hands of New Britain. In between, the Altoona Curve fashioned their most successful season in the history of the franchise with an 85-56 mark, good enough for their lone championship, the Eastern League's Southern Division title. Three Curve players, second baseman Jeff Keppinger, catcher Ronny Paulino, and pitcher Ian Snell, made the postseason all-star team while a team-record six sluggers finished the season with 10-plus homers in leading the club to a five-and-a-half-game margin for the pennant over its in-state rival, the Erie Seawolves. (Below, courtesy of the Altoona Curve.)

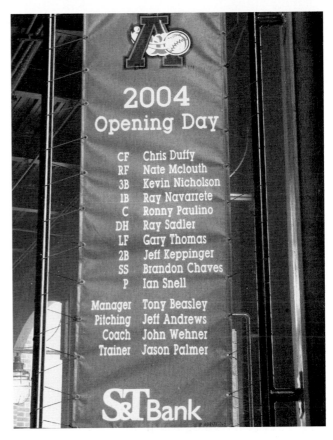

2004 Opening Day

CF	Chris Duffy
RF	Nate Mclouth
3B	Kevin Nicholson
1B	Ray Navarrete
C	Ronny Paulino
DH	Ray Sadler
LF	Gary Thomas
2B	Jeff Keppinger
SS	Brandon Chaves
P	Ian Snell
Manager	Tony Beasley
Pitching	Jeff Andrews
Coach	John Wehner
Trainer	Jason Palmer

S&T Bank

Following a run as manager in the Pirates organization, where he led two teams to league championships in three years while compiling a 211-136 record, Tony Beasley was named manager of the Curve in 2004. The Virginia native promptly led the club to its lone Southern Division title, being named *Baseball America*'s Double-A Manager of the Year. Currently Beasley is a minor-league infield coordinator for the Bucs. (Courtesy of the Altoona Curve.)

The first overall pick in the 2002 draft out of Ball State University, Bryan Bullington was with the Curve in 2004 after finishing 13-5 with Hickory and Lynchburg in his first professional campaign. Bullington started off quickly with Altoona, not allowing an earned run for his first 14 1/3 innings. He compiled a 12-7 mark, second in the Eastern League in wins, while being named to the midseason all-star squad. (Courtesy of the Altoona Curve.)

Being named team MVP during the championship campaign in 2004, center fielder Chris Duffy proved that he was more than just a great defensive presence; he could hit too. The career leader in stolen bases for the Curve with 66, Duffy hit .309 his second season in Altoona and was named as the Eastern League's best defensive outfielder by *Baseball America*. (Courtesy of the Altoona Curve.)

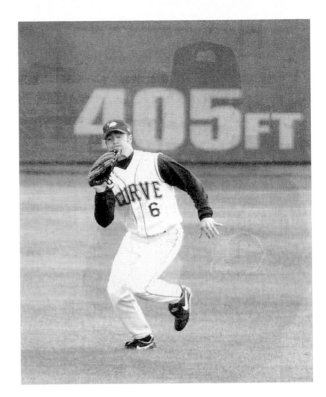

One of the most honored minor-league pitchers in the Pirates' minor-league history, Zach Duke made a short yet effective stop in Altoona in 2004, going 5-1 with a 1.58 ERA. During the first game of the divisional series against Erie, the 20th-round pick from Midway (Texas) High School etched his name in the annals of Curve baseball as the winning pitcher in a 14-2 shellacking of the Seawolves. (Courtesy of the Altoona Curve.)

In 2004, slugger Brad Eldred had one of the most productive minor-league seasons a member of the Pirates organization has ever experienced. The Fort Lauderdale native smacked 38 homers and a minor-league-high 137 RBIs in 130 games with Lynchburg and Altoona. For his efforts, Eldred was named the Bucs' Minor League Player of the Year. (Courtesy of the Altoona Curve.)

When outfielder Nate McClouth made his visit to Altoona in 2004, he certainly seized the opportunity, having one of the greatest seasons in team history. Leading the league in hits (166), doubles (40), and runs (93), McClouth, who also hit .322, set the club record twice for consecutive games, reaching base safely with a 30- and 32-game streak that season.

Following his successful season in Altoona, Bryan Bullington had a nice start in Indianapolis in 2005 before realizing his dream with a call up to Pittsburgh on September 16. What should have been the beginning of a long career in the majors ended up just the opposite. Bullington suffered an injury to his right shoulder and had surgery, which kept him out of action in 2006. (Courtesy of the Altoona Curve.)

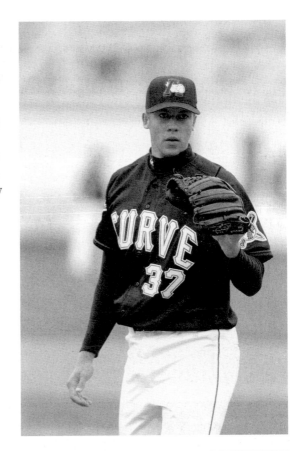

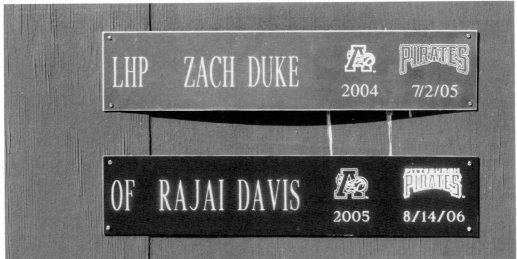

Two important members of the Curve during the 2004 and 2005 campaigns are showcased on the team's Road to the Show wall that honors every Altoona player to make it to the majors. Zach Duke got his start in July 2005, having a phenomenal rookie season at 8-2 with a 1.81 ERA, while Rajai Davis made it to the Pirates a year later following a fine season with Indianapolis.

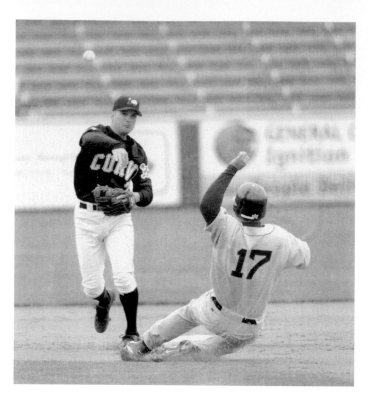

After a solid season in Lynchburg, where he hit .325, University of Georgia alumnus Jeff Keppinger had a phenomenal campaign for the Curve in 2004. The second baseman compiled an Altoona record .334 average before he was sent to the New York Mets in the Kris Benson trade. Keppinger was assigned to Binghamton of the Eastern League and continued his fine campaign, leading the circuit in hitting with a .341 mark. (Courtesy of the Altoona Curve.)

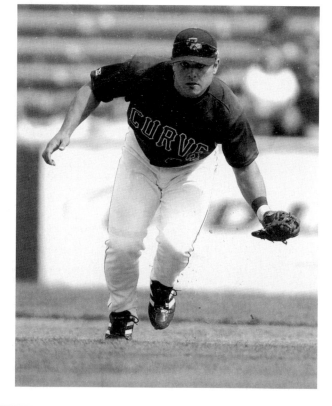

After showing that the former first-round draft pick had a chance to live up to his potential with a fine 2003 campaign, Kevin Nicholson took a huge step backward in 2004, slumping with a .217 average. Following the season, Nicholson was released by the Pirates organization, spending the past two years with Somerset of the independent Atlantic League. (Courtesy of the Altoona Curve.)

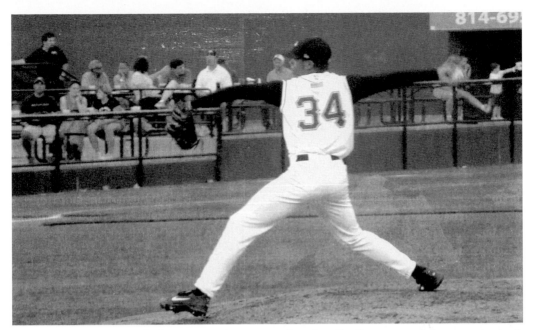

His meteoric rise through the minors almost complete, Ian Snell was one of the organization's best pitchers in 2004. Allowing only one earned run or less in 9 of his first 15 starts, Snell went 11-7 for the Southern Division champions while mowing down a Curve-record 142 opposing batters. The Dover, Delaware, native was named to both the midseason and postseason Eastern League all-star teams. (Courtesy of the Altoona Curve.)

Members of the armed forces perform at Blair County Ballpark before what was another huge crowd in 2004. During that memorable season, a record 394,062 passed through the turnstiles at the tune of a franchise-high 5,970 fans per game. That season, the franchise also passed an impressive milestone as it saw the two millionth fan, Jim Scott of nearby Tyrone, enter the facility. (Courtesy of the Altoona Curve.)

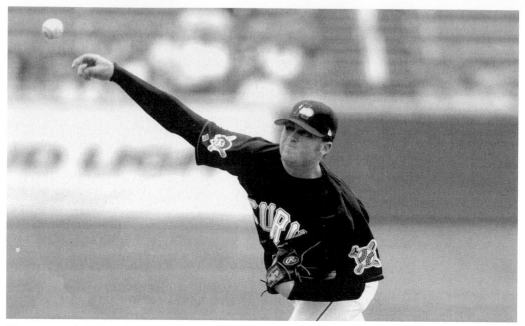

The poster child for the Pirates' problems during this less-than-stellar era, Bobby Bradley was supposed to be their savior when he was chosen as their first-round pick in the 1999 draft. After an 8-2 season in Hickory in 2000, *Baseball America* named him the best prospect of Class A ball. A year later, he had Tommy John surgery, and with injuries mounting, he was released from the organization in 2005. (Courtesy of the Altoona Curve.)

By 2004, the Altoona Curve was becoming one of the absolute jewels of all minor-league teams. They were Southern Division champions on the field while the front office was awarded the Larry MacPhail Trophy, emblematic of the minor-league team that is the most effective at promotions both on and off the diamond.

After recovering from surgery to his right knee in 2002, Ben Shaffar made it back to Altoona in 2003 following a rehabilitation stint with the Pirates' Gulf Coast League rookie-league team. Shaffar struggled at first but by 2005 became its closer, finishing 24 games with nine saves and a 3.34 ERA. (Courtesy of the Altoona Curve.)

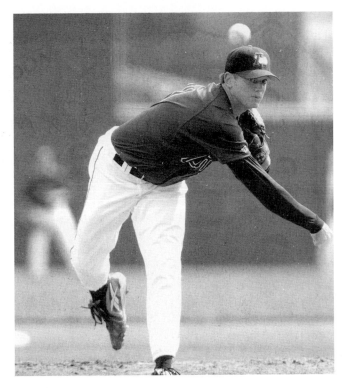

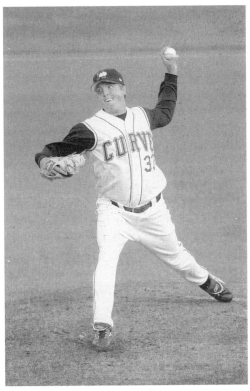

Making his Curve debut in the 2004 Eastern League Divisional Series playoffs against Erie, fireballer Tom Gorzelanny showed the Pirates organization just how special he could be when shutting out the Seawolves in five innings of relief, earning his first Altoona victory. That year, the second-round pick was also named the Bucs' No. 5 prospect by *Baseball America*. (Courtesy of the Altoona Curve.)

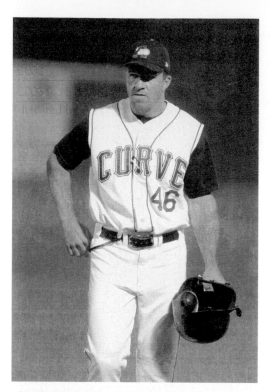

Altoona Curve coach and former Pittsburgh Pirate John Wehner embarked on a new career following his three-year tenure with the Pirates' Double-A affiliate. The former utility infielder was hired by the Pirates as a color analyst, sharing the booth with legendary play-by-play man Lanny Frattare as well as Greg Brown, Bob Walk, and Steve Blass. (Courtesy of the Altoona Curve.)

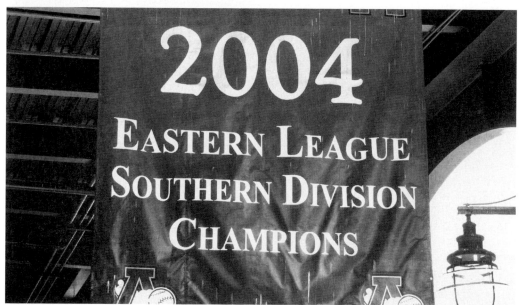

This banner hangs on the upper concourse of Blair County Ballpark and celebrates the lone championship in the franchise's nine seasons. After sweeping the Erie Seawolves in the divisional series, the Curve took on the New Hampshire Fisher Cats in the club's only appearance in the Eastern League Championship Series. While each game was close, Altoona was swept by the Fisher Cats in the best-of-five tilt.

Beginning the defense of their Southern Division championship, the Curve began the 2005 campaign winning four of their first five games. Led by an offense that smacked a team-record 141 homers, Altoona once again qualified for the postseason, finishing second to the Akron Aeros. Winning 76 games, the Curve became the only team in the Eastern League to win 70-plus games four years in a row.

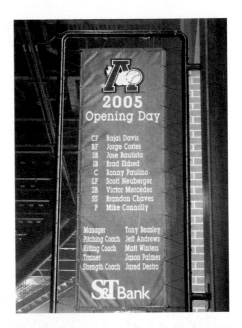

A member of the 2003 national champion Rice Owls, Craig Stansberry came to the Altoona Curve in 2005 with a reputation as a good glove man, being named by *Baseball America* as the Pirates' best defensive infielder in their system. Stansberry, who was born in Saudi Arabia, also proved to have some power, hitting 18 long balls with the Curve after being promoted from Lynchburg early in the season. (Courtesy of the Altoona Curve.)

Being drafted by the team one's father is general manager for can be pressure all on its own, but when one's father is fired from the organization, it can take that pressure to a whole new level. Josh Bonifay's father, Cam, was the Bucco general manager when Josh was taken by the Pirates in the 24th round of the 1999 draft. What was once a situation where fans accused Josh of being in the organization because of nepotism now became one where the University of North Carolina–Wilmington alumnus was not sure what would happen to him when Cam was fired in 2001. In an interview for the Pirates report, Josh confided, "At first, when he got fired, I felt a discomfort from the organization just because of the fact that I didn't know where I was going to be —I didn't know where I was headed or if I was going to be released the day after it." Luckily for Curve fans, the organization kept him as Josh Bonifay spent three years in Altoona becoming the franchise's all-time home run leader with 55. (Courtesy of the Altoona Curve.)

A second-team All-American in 2003 when he starred for the University of Northern Iowa, outfielder Adam Boeve was the Pirates' 12th-round draft selection the same year. The Rock Valley, Iowa, native, who started at Northern Iowa on a football scholarship, showed the Bucs his offensive potential with Hickory in 2004 when he smacked 28 homers, knocking in 92. (Courtesy of the Altoona Curve.)

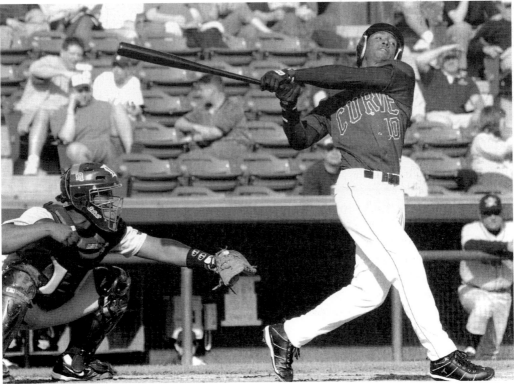

A speedster out of Inglewood, California, outfielder Vic Buttler seemed stalled in the Pirates organization until he broke out, hitting .333 with Lynchburg in 2005 before moving on to Altoona. In the following campaign, Buttler kept up the fine pace with a team-record 14 triples and 21 steals and was named to both the mid- and postseason Eastern League all-star teams. (Courtesy of the Altoona Curve.)

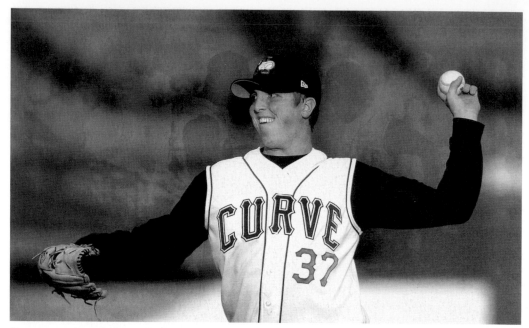

Staying in extended spring training before the 2005 campaign because of discomfort in his left elbow, Tom Gorzelanny made his regular-season debut for the Curve a month after the season started and showed no ill effects from the injury. Gorzelanny went 8-5 and was selected for the circuit's all-star game. By the end of the year, Gorzelanny was in Pittsburgh and today is one of the Bucs' best pitchers. (Courtesy of the Altoona Curve.)

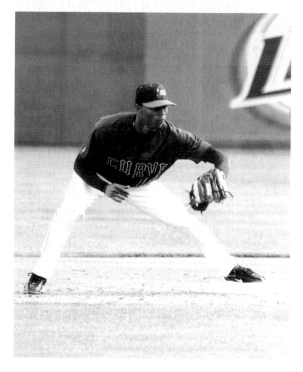

An all-star at Lynchburg with a .324 average in the first half of the 2005 campaign, Javier Guzman was promoted to Altoona on June 20, and he hit safely in 15 of his first 19 games with the Curve. Eventually Guzman slipped, finishing the year with a .236 average, but the Bucs thought enough of Guzman's talent to include him on the 40-man roster. (Courtesy of the Altoona Curve.)

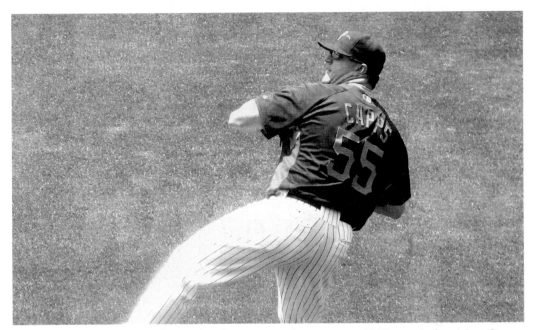

One former Curve player who made a big jump in the majors in 2007 was pitcher Matt Capps. Following a decent season with the Curve in 2005, his first full-time campaign in the bullpen, Capps was a surprising addition to the big club in 2006. Going 9-1 in an incredible 85 games his rookie season, he replaced Solomon Torres in the closer role for the club on June 1, 2007.

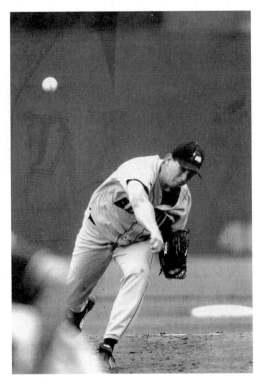

With his career in question after surgery on his right shoulder ended his 2004 campaign, Landon Jacobsen came back very sharply in 2005. The South Dakota native was 6-2 in rehabilitation assignments for Lynchburg and Bradenton before returning to the Curve. Coming out of the bullpen for the first time in his career, Jacobsen was 2-0 in 11 games for Altoona. (Courtesy of the Altoona Curve.)

Following his monster year with Hickory, Adam Boeve continued his rise in the Pirates system in 2005, hitting .313 with Lynchburg before he made the jump to Altoona on July 14. The former quarterback continued his fine play on the diamond with the Curve the remainder of the 2005 campaign. In 2006, he had a phenomenal start where he hit .380 in April, earning Boeve the Eastern League's Player of the Month. The incredible start in Altoona earned the University of Northern Iowa alumnus a promotion to Indianapolis, where he stumbled some, hitting only .269 for the Indians. Fortunately for Curve fans, even if it was unfortunate for Boeve, he was back in Altoona in 2007, continuing to be a pivotal part of the Altoona offense.

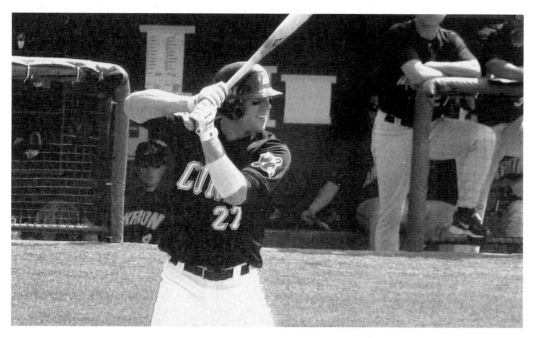

One of the Pirates' better prospects, Jose Bautista unfortunately was picked off the Pittsburgh roster in the Rule 5 draft by Baltimore in 2004. Perhaps realizing the huge mistake he made, Bucco general manager Dave Littlefield brought him back as part of the Kris Benson deal. Bautista did not disappoint as the future Pirates third baseman had one of the greatest Curve seasons ever in 2005 with 23 homers and 90 RBIs.

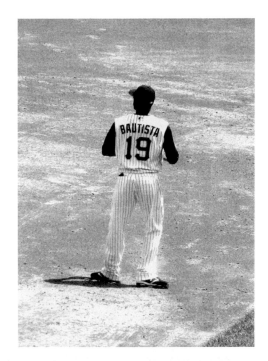

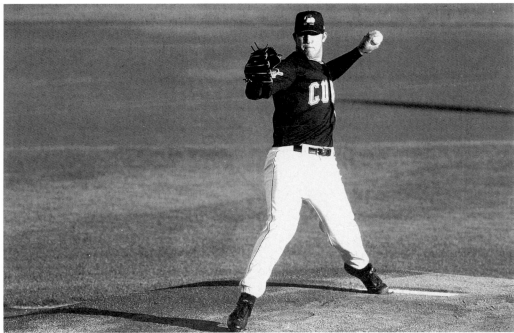

The Pirates' first-round pick out of Mississippi State University in 2003, Paul Maholm suffered a frightening injury in 2004 at Lynchburg when he was hit in the face by a line drive that broke his nose and fractured his orbital bone. The gritty southpaw fought back and began the 2005 campaign in Altoona, where he was 6-2 for the Curve, being named the organization's Minor League Pitcher of the Year. (Courtesy of the Altoona Curve.)

Obtained by the Pirates in 2003 for Randall Simon, Ray Sadler was sent to Altoona and in 2004 had a career year for the Curve. The Clifton, Texas, native showed uncharacteristic power that season, hitting 20 homers after only clouting 28 his first four seasons in professional ball. Sadler made it to the show a year later, and his first major-league hit was a home run against the San Francisco Giants. (Courtesy of the Altoona Curve.)

There have been few relievers that have put up as spectacular minor-league numbers for the Pirates as Allegheny College's Josh Sharpless. Sporting a 95-mile-per-hour fastball, the Beaver native surrendered on seven hits in 27 innings for Lynchburg in 2005 with a perfect 0.00 ERA. A year later, he was just as impressive, giving up eight hits in 21 innings for the Curve with a miniscule 0.86 ERA. (Courtesy of the Altoona Curve.)

THE 2004 AND 2005 CURVE

He came to Altoona in 2004 and made an impact on the franchise that was of monumental proportions. Brad Eldred was selected in the sixth round of the 2002 draft, and it was thought that the Florida International University alumnus would become the incredible power source that had been missing from the Pirates lineup for over two decades. That power first manifested itself in Hickory with 28 long balls in 2003, but it really took hold the next year. That was the season that Eldred smacked 21 homers in 91 games for Lynchburg before being promoted to Altoona on July 21. Nine days later, he took an assault on the Eastern League, hitting 14 homers and an incredible 50 RBIs in August. While the record for RBIs in a month for the minors is unknown, the 50 RBIs is three short of the major-league mark that hall of famers Hack Wilson and Joe DiMaggio hold. Overall, Eldred hit 30 homers and 87 RBIs in 60 games for Altoona. (Courtesy of the Altoona Curve.)

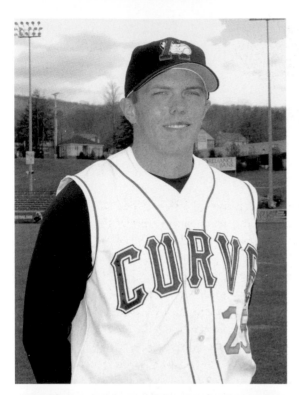

Picked by the San Diego Padres in the 2004 Rule 5 draft before being traded to the Kansas City Royals, outfielder Rich Thompson got the opportunity to live his dream by making it to the majors to start the season. After going hitless in six at bats, he was returned to the Bucs system. A year later, Thompson made his debut for the Curve and stole a team-record 45 bases. (Courtesy of the Altoona Curve.)

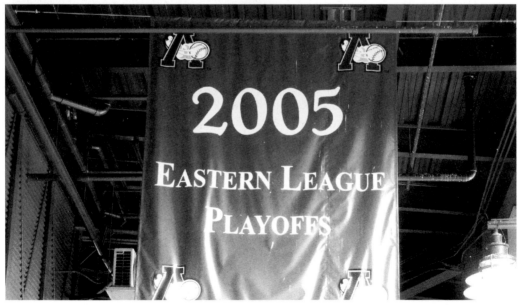

Despite the fact they were unable to defend their 2004 Southern Division crown, the Curve still qualified for their third consecutive playoff appearance, finishing second to the Akron Aeros. The divisional series was a classic, each team splitting the first four games with the home team winning every game. The fifth and final game was at Akron, and unfortunately the streak held true with the Aeros winning 6-4.

THE 2006 AND 2007 CURVE

While 2006 did not end with its first Eastern League championship, which was the hope after three consecutive playoff appearances, it, nonetheless, was a banner year for the franchise.

It started off with the introduction of Blair County Ballpark's newest addition, a $1 million, 1,000-square-foot mammoth scoreboard that is among the biggest scoreboards in all of minor-league baseball. It was the latest in a string of incredible improvements that Chuck Greenberg and company have made to the facility in their six years since they took over the club.

What took place afterward was the thing memorable seasons are made of. A fourth consecutive playoff appearance was in the cards as Altoona, led by Shane Youman's team-record 1.51 ERA, finished in second place once again to its rivals from Akron. Brandon Knight topped the Eastern League in saves with 27, and six Curve players were selected to play in the midseason classic, which would be held at Blair County Ballpark.

A record crowd of 9,308 witnessed the festivities as the Southern Division topped the north 5-3 with Brett Roneberg knocking in two runs with a single in the bottom of the eighth, capping off a three-for-five, three-RBI evening. The performance gave the Australian the game's Star of Stars award, the second time that a Curve player captured the game's MVP (Jeff Keppinger captured it in 2004).

Despite all the heroics, the season still ended as it had the year before, with a disappointing five-game loss to Akron in the divisional playoff series.

Top prospects Neil Walker and Andrew McCutchen came up to Altoona late in 2006 and gave the club hope for that elusive title in 2007. A 10-game losing streak in late May and a horrendous slump by McCutchen to begin the season doomed Altoona's championship hopes early on. On the plus end, though, a solid year by Walker, the emergence of a potential superstar in Steve Pearce, and the resurrection of former phenom Matt Peterson, when he was moved from the starting rotation to the closer position, made 2007 yet another season to remember. The Curve's 2006 and 2007 statistics as well as a list of the top 25 Curve seasons of all time appear on the following page.

Year	Wins	Losses	Percentage	Games behind	Place	Average attendance
2006	75	64	.540	10.5	2nd*	5,536
2007	73	68	.518	8.5	3rd	5,318

*defeated by Akron 3-2 in the Eastern League Divisional Series (best of five)

Top 25 Curve Seasons of All Time
(Hitters' numbers read home runs-RBIs-average unless otherwise noted, and pitchers' numbers read wins-losses-ERA unless otherwise noted.)
1) Adam Hyzdu in 2000 (31-106-.290, Eastern League MVP)
2) Sean Burnett in 2003 (14-6-3.21, Eastern League Pitcher of the Year)
3) Brad Eldred in 2004 and 2005 (combined 60 games played, 30-87-.299)
4) Steve Pearce in 2007 (14-72-.334, Minor League Baseball Offensive Player of the Year)
5) Shane Youman in 2000 (7-2-1.51, Eastern League mid- and postseason all-star)
6) Sam McConnell in 2006 (9-2-1.61, Eastern League mid- and postseason all-star)
7) Adam Hyzdu in 1999 (24-78-.316, Eastern League midseason all-star)
8) Jeff Keppinger in 2004 (1-33-.334, led Eastern League in hitting)
9) Jose Bautista in 2005 (23-90-.283, Eastern League mid- and postseason all-star)
10) Carlos Rivera in 2002 (22-84-.302, Eastern League postseason all-star)
11) Matt Peterson in 2007 (4-2-1.98, 29 saves, Eastern League postseason all-star, led league in saves)
12) Brandon Knight in 2006 (2-7-2.25, 27 saves, led Eastern League in saves)
13) Ian Snell in 2004 (11-7-3.16, 142 strikeouts, Eastern League mid- and postseason all-star)
14) Wilson Guzman in 2000 (10-4-3.02, Eastern League postseason all-star)
15) Josh Bonifay in 2005 (25-77-.282, Eastern League mid- and postseason all-star)
16) Tom Gorzelanny in 2005 (8-5-3.26, 124 strikeouts, Eastern League midseason all-star)
17) Nate McClouth in 2004 (8-73-.322, led Eastern League in runs scored)
18) Mike Johnston in 2003 (6-2-2.12, 72 1/3 innings pitched, 49 hits, Eastern League midseason all-star)
19) Bronson Arroyo in 1999 (15-4-3.65, tied for Eastern League lead in wins)
20) Chris Duffy in 2004 (8-41-.309, 33 stolen bases, Eastern League midseason all-star)
21) Tony Alvarez in 2002 (15-59-.318, Eastern League postseason all-star)
22) Landon Jacobsen in 2006 (14-9-3.21, Eastern League midseason all-star)
23) Zach Duke in 2004 (5-1-1.58 in nine starts)
24) Rob Mackowiak in 2000 (13-87-.297)
25) Vic Buttler in 2006 (5-51-.292, 21 stolen bases, Eastern League mid- and postseason all-star)

Coming off their third-straight playoff appearance in 2005, the Altoona Curve set their sights on adding that elusive Eastern League crown to their resume in 2006. While they fell short, losing to the Akron Aeros in the divisional series, it still was a banner year as the club extended its postseason streak to four years in a row and finished second in the circuit in both ERA (3.56) and average (.262).

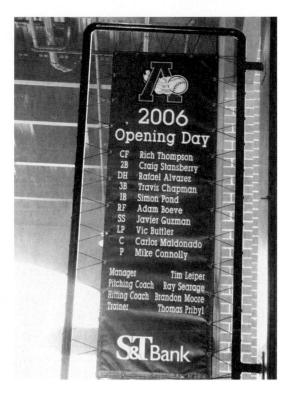

After five years out of affiliate baseball where he split his time between the independent leagues and the Mexican leagues, outfielder Rafael Alvarez signed with the Bucs following the 2005 campaign and was assigned to Altoona. Discovered by the Pirates in Venezuelan winter ball, Alvarez did not enjoy much success, hitting only .250 in 78 games before a bruised ankle sent him to the disabled list. (Courtesy of the Altoona Curve.)

The future of the Pittsburgh Pirates came to Blair County Ballpark in 2006 when catcher Neil Walker (left) and center fielder Andrew McCutchen (below) were called up to Altoona from Lynchburg and Hickory, respectively, on August 15. The Bucs' first-round picks in 2004 and 2005 were having standout years in Class-A ball when each was promoted. After a great start for Walker when he homered at Connecticut in his first game, a viral infection sent him to the disabled list as he hit .161 in 10 games. McCutchen had no such issues as the Fort Meade, Florida, native continued his fine season, breaking the .300 barrier in a Curve uniform with a .308 average. (Courtesy of the Altoona Curve.)

THE 2006 AND 2007 CURVE

A former University of Northern Iowa standout, Adam Boeve was given one of the ultimate honors when he was named to the Missouri Valley Conference's all-centennial team in May 2007. While at Northern Iowa, Boeve was incredible and was named the Missouri Valley Conference's Player of the Year in 2003 after he led the conference in runs, homers, and total bases while being among the leaders in just about every other offensive category. (Courtesy of the Altoona Curve.)

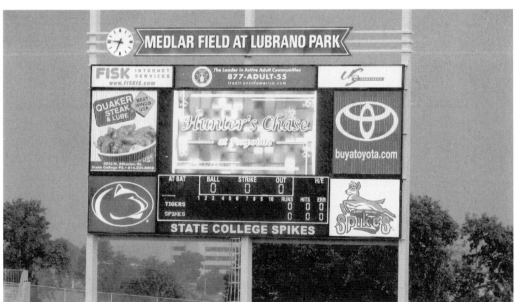

Proving they knew how to run a minor-league franchise with the incredible success they had in Altoona, Chuck Greenberg and his partners added another team to their stable before the 2006 campaign, the State College Spikes. Playing in a state-of-the-art facility, Medlar Field at Lubrano Park, the Spikes were the New York-Penn League affiliate of the St. Louis Cardinals before signing an agreement with the Bucs in 2007.

Manager Tim Leiper hands in his lineup to the umpires prior to a game against the Akron Aeros. Playing for 12 years in the minors, where the native of Canada hit .273, Leiper has shown that he is perhaps more suited to the bench as he has compiled an impressive résumé with a 479-431 mark as a manager in eight seasons with the Expos, Red Sox, Orioles, and Pirates organizations.

The Pittsburgh Pirates' 2001 first-round draft pick, John Van Benschoten had his dream of being a star pitcher for the Bucs put on hold in 2004 when he had major shoulder surgery that shelved the Kent State University alumnus for the entire 2005 campaign. As part of his rehabilitation in 2006, Van Benschoten started one game for the Curve, a 4-2 victory against the Connecticut Defenders on August 14. (Courtesy of the Altoona Curve.)

Coming out of San Diego State University, where he had the reputation of a fine defensive infielder, Taber Lee hit .333 in his career for the Aztecs (although he was homerless). Regardless, some questioned the Bucs when they made him their third-round pick in the 2002 draft. So far the jury is still out on Taber as he has hit only .238 in his minor-league career to date. (Courtesy of the Altoona Curve.)

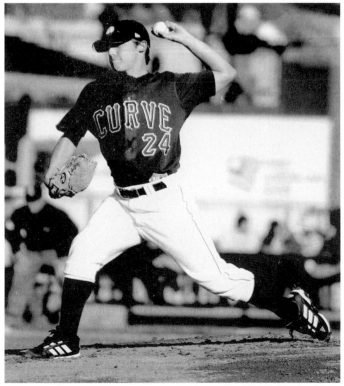

While the 2006 campaign was not one of the best for 23-year-old Mike Connolly, the Curves all-time leader in wins (with 30) did have his moments. The week ending May 28 was a memorable one as the Connolly went 2-0 with a 1.23 ERA as he set the franchise's all-time career win record with a victory over Erie while being named the Eastern League's Player of the Week. (Courtesy of the Altoona Curve.)

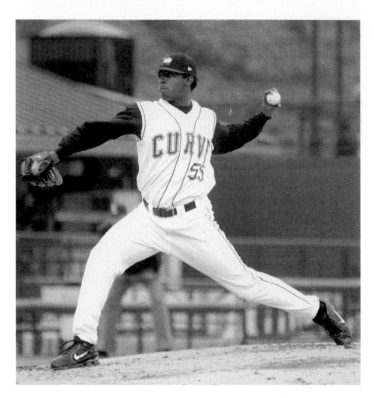

After having marginal success as a middle reliever since the Louisiana State University product was drafted in the 43rd round of the 2000 draft, southpaw Shane Youman was switched to the starting rotation with the Curve in 2006. The move was very fortuitous, as Youman set the all-time franchise low for ERA with a 1.51 mark while going 7-2. By September, his improbable season continued with a call to the Pirates. (Courtesy of the Altoona Curve.)

As good a baseball player as speedy outfielder Nyjer Morgan is, hockey was the first sport he chose to pursue. At 16, he began his career in Canadian junior hockey for the Regina Pats, playing for four seasons before switching to baseball. Drafted by the Bucs in 2002, Morgan hit .306 in 2006 and has scorched the basepaths in his professional career, swiping 164 bases. (Courtesy of the Altoona Curve.)

A 14th-round pick of the Texas Rangers in 1995, hurler Brandon Knight spent six years in the minors before getting a short-lived opportunity with the New York Yankees in 2001 and 2002. After two plus-10 ERA campaigns for the Bronx Bombers and an unsuccessful season for Nippon in the Japanese league in 2005, Knight joined up with the Curve in 2006 and saved a team-record 27 games. (Courtesy of the Altoona Curve.)

Second baseman Craig Stansberry did not enjoy a banner year in the Pirates organization in 2006, hitting only .258 with the Curve in 72 games and a paltry .223 at Indianapolis. The fifth-round pick was released by the Bucs and picked up by San Diego in December, where he enjoyed a fine season with the Padres' Triple-A team in Portland, Oregon. (Courtesy of the Altoona Curve.)

Despite the fact he has a 93-mile-per-hour fastball and an impressive curveball in his repertoire, pitcher Josh Shortslef has had a rather bumpy road through the Pirates organization to date. Spending six seasons at the Class-A and rookie-league levels, Shortslef made the leap to Altoona in 2006 and was off to a decent start when he strained his forearm and was out for two and a half months. (Courtesy of the Altoona Curve.)

The 2006 Pirates Minor Leaguer of the Year, Andrew McCutchen signs an autograph for a Curve fan before a game. While an incredible baseball player for Fort Meade High School, where he was the 2005 Gatorade Player of the Year in Florida, McCutchen was also a talented football player, ranked in the top 200 players in the state, and a member of the state champion 4-by-100 relay track team.

In 2006, most of the baseball world converged on Pittsburgh to see the Major League Baseball All-Star Game; a day later, the festivities moved to Altoona for the Eastern League's midseason classic. After a fabulous all-star gala that included a concert by Eddie Money, 9,308 fans jammed into Blair County Ballpark to see a classic contest that the hometown Southern Division won 5-3.

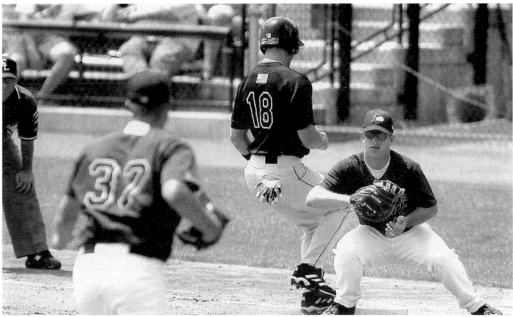

It was only fitting that the star and MVP of the 2006 Eastern League All-Star Game would hail from Altoona. Brett Roneberg, the Australian outfielder, was three for five with three RBIs, including the game-winning hit, was also the team's MVP for the entire campaign, hitting a career-high .303 with 10 homers while knocking in 74. (Courtesy of the Altoona Curve.)

"Altoona is one of the class organizations in the minor leagues," Pittsburgh farm director Brian Graham said in an article in *Baseball America* honoring the Curve for winning the 2006 Bob Freitas Award, emblematic of the top minor-league franchise in Double-A baseball. The award is given to the team that is, according to the magazine, "on a path of long-term excellence and are true parts of their communities."

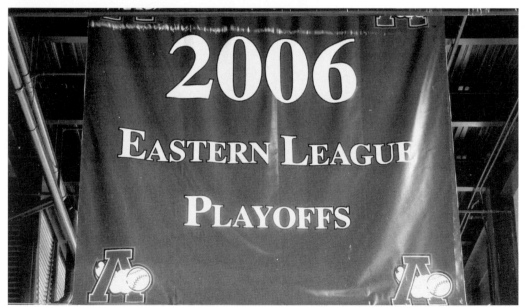

With another successful campaign in their back pockets, the Curve took one more venture into the postseason to see if they could finally win that elusive Eastern League crown. Facing off against, once again, the Aeros, Altoona won both its games at home, sending the series back to Akron for the fifth and final game. Unfortunately, for the fourth consecutive year, the Curve came up short again, with a 5-2 loss.

It was a season that began with anticipation as the two top prospects for the Pirates were coming to Altoona. Neil Walker and Andrew McCutchen were in the lineup as the team tried to extend its postseason streak to five years. A snowstorm in Erie, which cancelled the first series, was an ominous sign for the club, as was a 10-game losing streak, which crippled its playoff hopes, ending the postseason streak at four seasons.

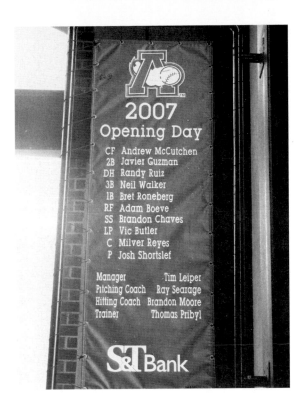

There are three significant awards that a minor-league franchise can win, and it is a rarity when one team wins all three. After capturing the Larry MacPhail Trophy and the Bob Freitas Award, the Curve became one of those rare teams when they were awarded the John H. Johnson Presidents Trophy (pictured here), emblematic of the best minor-league franchise in the country, minor-league baseball's highest honor.

The grandiose plans of a rapid ascent to the big leagues by the end of the 2007 season for Andrew McCutchen were put on hold when the phenom had a horrific start to the season. Batting only .189 in April and .230 in May for the Curve, McCutchen experienced his first true struggle in his professional career. McCutchen did hit well down the stretch, finishing the year with a .258 average.

Rated as the top prospect in the Bucco system before the 2006 campaign began, preseason wrist surgery to repair torn ligaments slowed down the progress of Neil Walker. The hometown hero, who graduated from Pine-Richland High School near Pittsburgh, eventually made it back, hitting .284 for Lynchburg before his late-season promotion to Altoona.

THE 2006 AND 2007 CURVE

Probably the one prospect whose stock rose quickly in 2006 was first baseman Steven Pearce. A second-team All-American out of the University of South Carolina, where he was the fastest Gamecock to reach the 40 home run plateau, Pearce exploded onto the scene, smacking 26 homers and 98 RBIs between Hickory and Lynchburg. Having vast offensive potential, Pearce also is very adept defensively at first.

Winner of the Curve's initial Unsung Hero Award in 2006, shortstop Brandon Chaves resigned with the Pirates organization after becoming a minor-league free agent in the off-season. Only a .233 career hitter, Chaves, who came back from serious knee surgery in 2004, had his best year in his four seasons with Altoona in 2007, a campaign that included an 11-game hitting streak.

After a solid 2006 for both Altoona and Indianapolis, Vic Buttler's 2007 campaign started off on the wrong foot. Beginning the year in Altoona for the third consecutive season, a strained right hamstring put the speedy outfielder on the disabled list for two months. After a short rehabilitation stint in Bradenton, Buttler returned to Altoona on June 28 and once again became a pivotal part of the offense.

Probably the most interesting signing in the off-season for the Pirates was pitcher Yoslan Herrera. A Cuban defector whom Dave Littlefield inked to a three-year, $1.92 million contract, Herrera, who had not pitched competitively in almost three years, got off to a slow start with the Curve in 2007, compiling a 0-2 record with an 8.05 ERA. He would find his groove by June, improving to 3-1-3.60, finishing the year with a 6-9 mark.

Warming up Wardell Starling before an inning of a game against Akron is No. 6, Justin Elliott. A former 27th-round pick of the Minnesota Twins in 2001 before he was signed by the Pirates as a minor-league free agent, Elliott, who spent the first part of the 2007 campaign on the disabled list, has had minimal experience in his seven-year minor-league career with a mere 131 at bats.

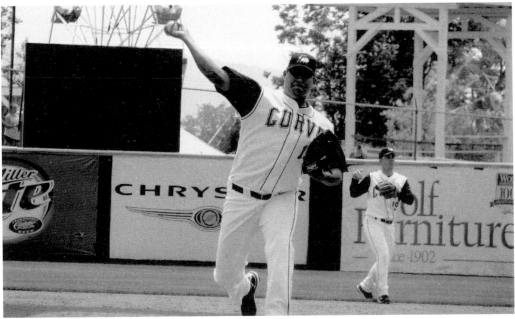

A member of the Bucs' 40-man roster, reliever Romulo Sanchez became a solid part of the Curve bullpen in 2007. Signed by the Pirates as a minor-league free agent out of the Dodgers organization in 2004, Sanchez tossed a no-hitter for the Pirates' Venezuelan team in San Joaquin against Ciudad Alienza on August 3, 2004.

Reaching for a throw from third baseman Neil Walker is first baseman Steve Pearce. The year 2007 proved to be a very important one for Walker as the first-round pick was switched from catcher, where he had been his entire career, to third base in spring training. While still learning the position with 19 errors in the first half of the season, Walker showed improvement as the season went on.

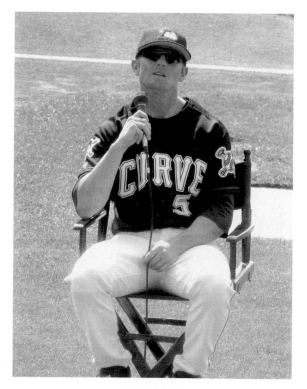

Answering questions from the fans in a question-and-answer session before a game is outfielder Matt Meath. A seven-year minor-league veteran in the Pirates system, Meath hit .273 in 33 at bats during the 2007 campaign as the Boca Raton resident made four trips to the disabled list with a bad left shoulder.

It has been 10 years since Altoona second baseman Jason Bowers was drafted by the St. Louis Cardinals, and throughout all that time, the Uniontown native always dreamed of playing for his hometown team. A Pirates fan as a kid, Bowers got a chance to be with his favorite club when he signed with the organization after the Baltimore Orioles released him following spring training.

As the season began, many experts thought Wardell Starling was going to be the breakout prospect in 2007. While he had consistency issues early on in his career, his 93-mile-per-hour fastball and decent changeup seemed to finally come together as he had a fine 2006 campaign, which pushed him up *Baseball America*'s chart as it rated him the 14th-best prospect in the Bucs system.

In 2007, pitching coach Ray Searage began his 30th year in professional baseball. Following a seven-year major-league career, the former Met, Brewer, White Sox, and Dodger embarked on a career as a coach in the minors. He began his stint in Altoona last season and was an immediate success, leading the club to the second-best ERA in the Eastern League.

Rated as the sixth-best prospect in the Pirates system by *Baseball America*, first baseman Steven Pearce proved that he may have been underrated. Starting off the season in Lynchburg, Pearce had a monster April, hitting 11 homers with 24 RBIs in 19 games before he was promoted to Double A. Pearce kept up the hot pace at Altoona, smacking 14 homers with a .334 average before being promoted to Indianapolis.

Signed by the Pirates organization in the off-season was outfielder Alex Fernandez. Coming off his first season out of affiliate baseball for the first time in his nine-year career, Fernandez had less-than-stellar results for the Curve in 2007, hitting only .219 with two home runs.

Looking on as the 2007 Minor League Baseball Offensive Player of the Year, Steven Pearce beats an Akron Aero to the bag is pitcher Wardell Starling. Coming into the season with so much hope after his impressive 2006 campaign, Starling had a less-than-stellar start in 2007 and was moved to the bullpen on June 10 after 102 consecutive starts.

BASEBALL IN ALTOONA

Catcher Brian Peterson, pictured watching Josh Shortslef (No. 56) catch a popup, is a favorite of his teammates, and manager Tim Leiper, who said on the team's Web site, "He plays the game right. He's a throwback guy, and has been real good for us." Signed by the Indians organization in 1999, the minor-league veteran is referred to by his teammates as "Crash," in reference to the movie *Bull Durham*'s main character Crash Davis.

Randy Ruiz came to Altoona in 2007 looking to rebuild his career. In 2005, Ruiz was having a banner campaign with Reading, threatening to capture the Eastern League triple crown, when he was suspended 30 games for substance abuse, his second suspension of the year. Ruiz was phenomenal for the Curve, hitting .290 with seven homers, when he was dealt back to the Philadelphia Phillies in May.

A 10-year minor-league veteran who was picked up by the Pirates before the season began, Jason Bowers took over the starting spot at second for the Curve. While he did not excel offensively, Bowers made the defensive play of the year diving to grab a line drive against Bowie on July 3 then turning on his right knee and firing a strike to home plate for an out.

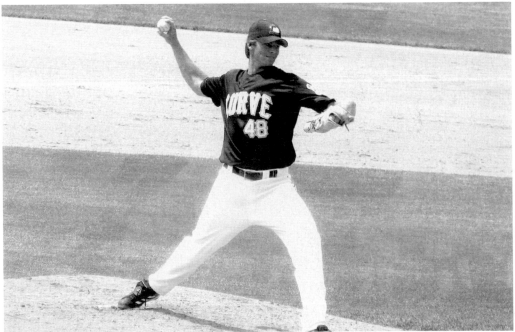

Beginning his career as a third baseman where he hit .237 in his first three professional seasons in the New York Mets organization, pitcher Jason Roach came to the Pirates as a minor-league free agent in 2005. A teammate of former Curve player Josh Bonifay at the University of North Carolina–Wilmington, Roach, shown above pitching, was converted to a full-time reliever in 2007 for the first time in his 10-year career.

Coming from Boston College, where he hit .336 and holds the school record for hits in a career with 256, is outfielder Jason Delaney. Delaney, who received his degree in finance at Boston College, got off to an incredible start in 2007 with Lynchburg, where he led the Carolina League in hitting with a .340 mark before he was promoted to the Curve on June 27.

The key ingredient of the Kris Benson trade to the New York Mets by the Pirates was pitcher Matt Peterson, who had struggled in Altoona for two and a half seasons. The former Mets organizational Pitcher of the Year's career was resuscitated in 2007 when the Curve moved him from the starting rotation into the closer's role. Peterson excelled as a closer, saving a league-high 29 games with a 1.98 ERA.

THE 2006 AND 2007 CURVE

With State College now part of the Pirates organization, Altoona fans do not have to travel far to see who the Curve players of the future will be. Pictured here is southpaw Tony Watson. Watson was a ninth-round selection in the 2007 draft out of the University of Nebraska and quickly became a star for the Spikes, with a 6-1 record and a 2.52 ERA.

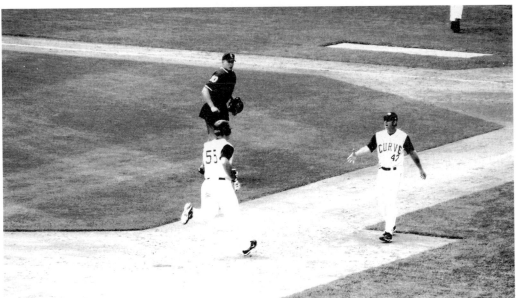

Being congratulated by manager Tim Leiper as he rounds third after a home run on July 25 against Binghamton is Jason Delaney (No. 55). After Delaney's incredible start with Lynchburg, the Bucs' 12th-round pick in 2005 continued to scorch pitchers, hitting .348 for the Curve in his first 29 games in Altoona. The home run above gave Delaney RBIs in 11 consecutive games, a franchise record, which he eventually extended to 12 games.

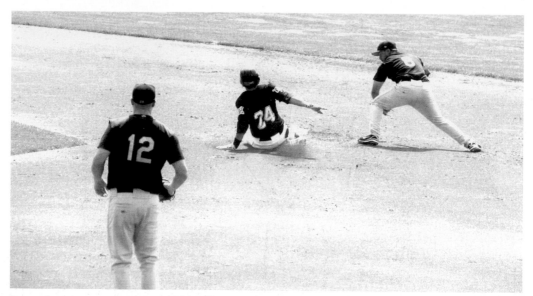

It was becoming apparent in 2007 that the two future building blocks that the Pirates would base their future around were going in different directions. Third baseman Neil Walker (No. 24), pictured above sliding into second base for a double, was showing the big club what he could do offensively, hitting .288 with 13 homers, while Andrew McCutchen (No. 10), a career .298 minor-league hitter who had shown flashes of power, was mired in a season-long slump, hitting only .258 with 10 long balls. Regardless how 2007 unfolded, the powers that be in the organization still believe these are their two future stars. It is projected that Walker could be a 30-plus home run man while McCutchen could be a more complete player with .300 potential, some power, and Gold Glove ability in center field.

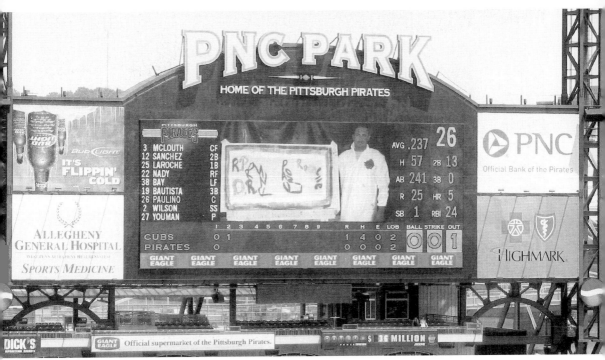

While winning games and entertaining fans are important things to minor-league franchises, their main purpose is to prepare players for the major-league teams they are affiliated with. Looking at the scoreboard at PNC Park shows the Altoona Curve have done their job as five of the starters this day, Nate McClouth, Josc Bautista, Ronny Paulino, Jack Wilson, and Shane Youman, are all Curve alumni. In fact, over the course of the nine seasons the team has been in existence, many Altoona players have found their way into the major leagues. As of the end of the 2007 campaign, 62 Curve players made their major-league debuts after playing in Altoona, while 119 players who have made their way through Blair County Ballpark have been on major-league rosters. They include the likes of Joe Beimel, Mike Gonzalez, Craig Wilson, and Kip Wells, who made a rehabilitation start with the club against Harrisburg in 2006 as 7,020 fans cheered on the former Pirate to a 6-3 victory.

ACROSS AMERICA, PEOPLE ARE DISCOVERING SOMETHING WONDERFUL. *THEIR HERITAGE.*

Arcadia Publishing is the leading local history publisher in the United States. With more than 3,000 titles in print and hundreds of new titles released every year, Arcadia has extensive specialized experience chronicling the history of communities and celebrating America's hidden stories, bringing to life the people, places, and events from the past. To discover the history of other communities across the nation, please visit:

www.arcadiapublishing.com

Customized search tools allow you to find regional history books about the town where you grew up, the cities where your friends and family live, the town where your parents met, or even that retirement spot you've been dreaming about.